The World's
TOP WEDDING
PHOTOGRAPHERS

Ten Top Photographers Share the Secrets
Behind Their Incredible Images

Bill Hurter

Amherst Media, Inc. ■ Buffalo, NY

About the Author

Bill Hurter started out in photography in Washington, DC, where he was a news photographer. He even covered the political scene – including the Watergate hearings. After graduating with a BA in literature from American University, he completed training at the Brooks Institute of Photography. Going on to work at *Petersen's PhotoGraphic* magazine, he held practically every job except art director. He has been the owner of his own creative agency, shot stock, and worked assignments (including two and a half years with the L.A. Dodgers). He has been directly involved in photography for the last three decades and has seen the revolution in technology. In 1988, Bill was awarded an honorary Masters of Science degree from the Brooks Institute of Photography. In 2007, he was awarded an honorary Masters of Fine Arts degree from Brooks; in 2009, he was awarded WPPI's prestigious Lifetime Achievement award. He has written over 50 books for professional photographers and is most recently the editor-in-chief of *Rangefinder* and *AfterCapture* magazines.

Copyright © 2015 by Bill Hurter.
All rights reserved.
Photographs in each chapter by the respective featured photographer, unless otherwise noted.

Front cover photograph by: Jose Villa.
Title page photograph by: Scott Robert Lim.
Back cover photographs by: Jonas Peterson (top) and Paul Ernest (bottom).

Published by:
Amherst Media, Inc.
P.O. Box 586
Buffalo, N.Y. 14226
Fax: 716-874-4508
www.AmherstMedia.com

Publisher: Craig Alesse
Associate Publisher: Kate Neaverth
Senior Editor/Production Manager: Michelle Perkins
Associate Editor: Barbara A. Lynch-Johnt
Associate Editors: Beth Alesse, Harvey Goldstein
Editorial Assistance from: Sally Jarzab, John S. Loder, Carey Miller
Business Manager: Adam Richards
Warehouse and Fulfillment Manager: Roger Singo

ISBN-13: 978-1-60895-855-9
Library of Congress Control Number: 2014955643
Printed in The United States of America.
10 9 8 7 6 5 4 3 2 1

Check out Amherst Media's blogs at: http://portrait-photographer.blogspot.com/
http://weddingphotographer-amherstmedia.blogspot.com/

Contents

Preface

The face of wedding photography has changed drastically over the last few years. Some couples seem now to be content with wedding-day "selfies" and a collection of cell phone images taken by guests and friends. Because these pictures get posted online, there is no need for an album. For these couples, gone are the storytelling aspects of the wedding coverage that used to be the mainstay of the wedding album—as well as any remnants of the formal wedding coverage that was so popular for so many years.

Yet, while the role of the professional wedding photographer has diminished and full-service wedding jobs are fewer and farther in-between, there continue to emerge great photographers for whom the public's changing tastes have not seemed to make a difference. This group of wedding photographers is doing well both financially and professionally. They are in demand with today's brides. That is where this book finds relevance. It is a "ten best" collection of these gifted contemporary photographers and a portfolio review of their work. Moreover, it is a review of their success in a difficult environment and a look at their ability to flourish when so many of their counterparts have failed to find lasting success in this challenging marketplace.

Choosing the Photographers

You might ask why these photographers made the list and not ten others. Using my past experience as editor-in-chief of *Rangefinder* and *AfterCapture* magazines and one of the architects of the WPPI Print Competition, I set out looking for photographers who were becoming well known because of their style. To put it another way: their success was directly related to the differences they posed with their competition. In more than one way, these people were unique and being well rewarded for their uniqueness.

Another reason I chose these photographers is their diversity. They represent a composite of the best wedding photography today. Their work ranges from the pure editorial/fine-art images of Dan O'Day to the highly stylized, romantic reality of Paul Ernest. As styles evolve, we look at cultures where change comes slowly, and thus I have included the work of MRK Palash of Bangladesh, where just making photographs outdoors was a major achievement for his studio. And then there are the purely brilliant photographers like Morgan Lynn Razi, and stylized, on-location lighting gurus Danny and Julia Dong and Dave and Quin Cheung. And then there is the sublime elegance of Jose Villa's fashion-inspired work and the visual dexterity of Scott Robert Lim and Roberto Valenzuela. Last but not least is Australian Jonas Peterson, who brings a special extravagance to the group. I am fond of all ten and their work and I love the fact that each of these photographers represents a different art form and a uniquely different style.

About This Book

Unlike past wedding books I have authored, this book is a series of in-depth profiles, in which the working methods of each of these photographers is revealed, along with their "secrets of success." This includes not just photography techniques but marketing methods, organizational habits and structure,

pricing, and many other aspects of their businesses. Accompanying the text is a portfolio of their images, so that you can delve into their unique artistic style.

With one exception (see my interview with Jose Villa), I sent each of the photographers a series of fourteen questions—but before I sent them out, I asked former *Rangefinder* and WPPI coworker Arlene Evans to review the questions to see if I was in the right neighborhood. She was positive in her response and sure the questions would reveal some great information. I also sought advice from long-time coworker and friend George Varanakis; he too agreed—especially on the lineup of featured photographers.

Here are the questions that went out:

1. Talk about your organizational abilities. How is your studio organized? How much time do you devote to studio work with your brides?
2. Describe your studio. How much do you need a studio in your business?
3. What are your sources of inspiration and creativity? Describe the internal resources that fuel your creativity. How do you pitch your style of weddings to your brides, or does it sell itself?
4. What equipment do you use—lights, cameras, lenses, computers, software, etc.?
5. Do you do the post or do you supervise it? Describe your postprocessing.
6. You are considered a big success in today's wedding market. What are the elements you believe are responsible for your success? What are some of the aspects that separate you from your competition?
7. What are some of your goals for the future? Where do you want to be in ten years?
8. What were you doing before you became a professional photographer? Did it prepare you for what you are doing now?
9. Describe in detail your most used photographic techniques and why they are your favorites.
10. What type of wedding photographer do you consider yourself to be (*i.e.*, journalistic,

traditional, fashion oriented, fine-art, etc.)?
11. In detail, please describe your philosophy of wedding photography.
12. In detail, please describe the elements that define your unique style.
13. Who were you most influenced by in your formative years?
14. Do you develop a game plan for each wedding? If so, describe the process.

Knowing photographers pretty well, I knew that every photographer would treat the questions somewhat differently. Some were diligent in answering all fourteen questions; others used the questions as a point of departure to explore some other aspect of their business. What I was certain of was that these talented photographers would open up and reveal the secrets to their success and their sources of inspiration and motivation.

Common Threads

One constant among every respondent was their passion for wedding photography and for their craft. Another is their exceptional work ethic. These folks are no strangers to long hours. But the trait I think I am seeing the most is fastidiousness. Each one of these photographers works extremely hard to create perfection in every image, and this unattainable standard keeps them striving.

These photographers each possess a certain special creative spark—an amazing energy that separates them from their contemporaries. They are not afraid to be different. That doesn't mean just occasionally trying a different approach to a traditional image, but rather an overarching desire to throw out the rule book and reinvent a new one as they go along. It's a daring philosophy, but it's one that I applaud and one that leads to unique and fresh styles. It's also one of the traits that has made them successful in this difficult economy. Today's brides want to see a unique style, and they would like to think that the photographer's style matches up closely with their own.

Additional similarities among the photographers interviewed here include the fact that most, but not all, are college-educated and a number have business degrees, including post-graduate degrees. Many have left good, secure, well-paying jobs to pursue a job in professional photography. In cases like this, it's a huge risk financially but one that produces the drive and commitment that is necessary to succeed. Some spouses have also left good jobs to join their husband or wife in the family wedding photography business. Even those without business degrees tend to have years of business experience—some in the family business. Almost all of the principals bring multiple skill sets to the wedding photography endeavor.

A character trait that is evident among virtually all of the photographers featured here is an air of self-confidence. This, I believe, is part of that drive and commitment that is also prevalent among this group. The confidence these photographers exude reassures clients that they are in good hands and that no problem is so large that it can't be solved.

Studios Are a Thing of the Past

Another similarity is the lack of a studio. While most of the featured photographers have everything they need to do studio-style shoots, these images tend to be created on location—a departure from the way it used to be done.

One of the reasons for this is the popularity and incredible dexterity of the small electronic flash—and its ability to be used off-camera in TTL mode. Multiple small flash units, triggered from the camera, allow these photographers to create exotic and widely varying types of lighting. You will see a great many examples on these pages.

Another reason why wedding businesses are "studio-less" is the higher cost of space. Without exception, the photographers in this book who do have an in-house studio have it literally *in their house*. It is more likely that they have a consultation area where sales meetings, image reviews, and album planning meetings take place. In most instances, photographers with this type of workspace have

redecorated their living quarters to accommodate their business, with lavish display areas for prints and albums, and perhaps a conference table with comfortable chairs.

Postproduction Is a Key Factor

The era of the darkroom is over, too, replaced by a postproduction area. Large monitors with powerful computers are capable of running the latest versions of Photoshop, InDesign, Lightroom, and Photo Mechanic with ease and great speed. A typical wedding studio might have four to six such workstations in the postprocessing area. Methods of batch processing for color correction and resizing come into play to speed the postproduction, and often photographers will employ an assistant or two to help with this process.

Not one of the photographers interviewed devalued the postproduction phase of image-making. Instead, they see it as a vital second half of the process. While it would be more cost-effective and time-efficient for the photographers to outsource their post work, most of them feel that it is crucial for them to at least oversee the process. Most see the unique and individual touches added during the postproduction process as a significant aspect of their style.

In Closing (and Thanks)

I truly enjoyed interacting with these ten photographers. They are a talented group, to say the least—and they offer widely varying points of view on the art and business of wedding photography. I wish to thank them all for their participation and enthusiasm.

I would also like to thank my son Nick and daughter Natalie, as well as my sisters Barbara and Jeanne, for their constant encouragement, which helped keep me on track and focused on deadlines.

Scott Robert Lim
Building a Signature Style

Internationally acclaimed master photographer Scott Robert Lim (Cr.Photog., AOPA) was awarded the prestigious Kodak Award (2009) and was inducted into WPPI's Society of Excellence. He has more than seventy international awards of excellence to his credit, and his work has been published in books and magazines distributed to more than one-million readers internationally. He has taught and mentored many professional photographers around the world. Scott is a popular international speaker with an exciting and inspirational style. *(www.scottrobertgallery.com)*

Scott's business is mostly done on location. "I don't own a studio," he says. "Ninety percent of my weddings are destination events and occur away from my home in the Los Angeles area. All my sessions are done on location, so it is not necessary to maintain a studio. I rarely meet a client face to face. If I do, I meet them at a four- or five-star hotel in my area. The look, feel, and style of a pleasant hotel represents my brand quite well. The hotel spends millions on decor that I can utilize at the very low cost of a few drinks and appetizers. I like to pick a place that has a nice ambiance but also decent lighting so they can view my albums. It is very relaxing to eat, socialize, and talk business. Not very many photographers would be willing to take their potential clients out to dinner, and I find doing this sets me apart from my competition.

"I feel comfortable spending 1 percent of my booking fee on a client. So if my average client spends $10,000 on my wedding package, then I would feel comfortable investing $100 on my client and buying them drinks. If I meet two clients a month and spend $200, this is a fraction of the cost of renting a studio and investing in decorating and furnishing it to impress a client willing to spend $10,000 or more on a wedding.

"When I meet a client, all I take are a couple albums. I have tons of imagery on my website, so they don't need to see any more images, but products are nice to touch and feel for clients."

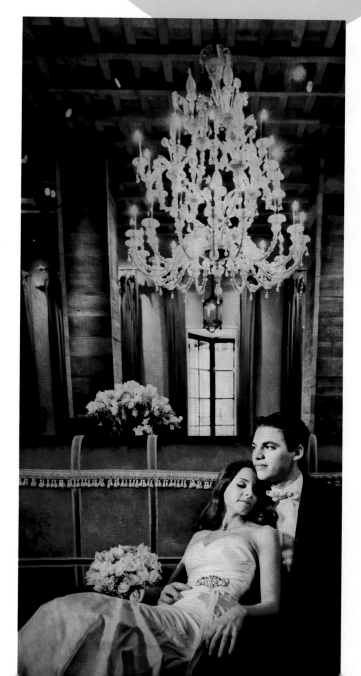

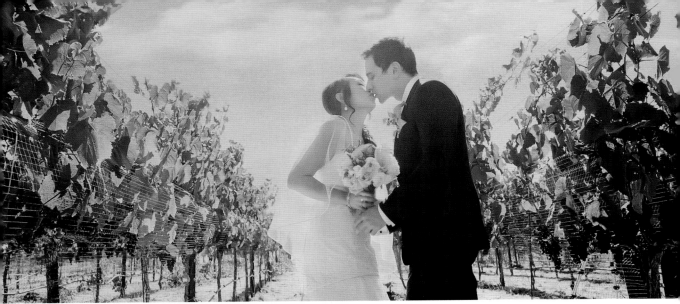

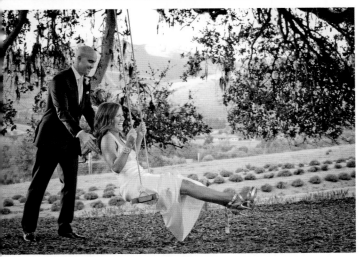

> "When I come across great ideas in any field—technology, science, business, etc.—it stirs my mind to move my business and art in new directions."

Passion and Inspiration

Asked about his sources of inspiration, Scott replied, "Beauty is my inspiration. There are so many forms of beauty, so I find myself constantly being inspired. I love to travel and to see the beauty of the world. When I get to experience new places, new cultures, it truly inspires me. I like to look at different forms of art, glean successful ideas from different genres, and bring them into my work. For example, for posing I like to look at great sculpture. If an artist can make a rigid slab of rock into a beautiful and graceful figure, this master artist has something to offer me in regards to posing the human form! For postprocessing, and portrait posing, I like to look at fine-art paintings. For

lighting and composition, I get inspired by viewing big-budget movies."

Scott finds excellence in any field is inspirational. "When I come across great ideas in any field— technology, science, business, etc.—it stirs my mind to move my business and art in new directions. I love to morph two successful ideas into another genre and create something entirely new.

"The key to being inspired is to be passionate. It is impossible to move our art, business, or success to another level without being passionate about it. Passion is the key to inspiration. Passion is the key to learning things others won't learn because they are not willing to sacrifice the time and effort needed to

discover the little nooks and crannies where pockets of gold are hidden. If a person is passionate about what they do, it is natural to be inspired all the time."

Self-Inspiration

Scott believes that every artist needs to become self-inspired. "This is the artist that is always excited about what they are doing, incorporating new ideas, taking new risks, and expanding their influence. The key to this is achievement. What prevents a photographer from becoming self-inspired is when he or she can't achieve a level of success in an area of their work.

"As I mentor photographers around the world, I see a destructive pattern—photographers don't invest the time to master fundamental posing and lighting techniques, so they become serial gadget users. They are always trying to find the next great postprocessing action, lighting gizmo, lens, camera, workshop, etc., to discover their signature style. Their limited success gets them down, and then they start to look for inspiration all over again. When that same photographer puts in the effort to master the fundamentals, he or she can grow and have success in other areas. It is an empowering feeling to have great success in our chosen field of endeavor. It inspires us to try and evolve, thus becoming self-inspired."

Wedding Style

After every successful booking, Scott asks the clients why they chose him. He says this gives him a good idea of what his signature style means to his client. He says, "My perceptions of my style can often be different from those of my clients. I try to learn new things about my work from my clients. I always try to combine fashion and glamor into my wedding photography; that's how I see my wedding

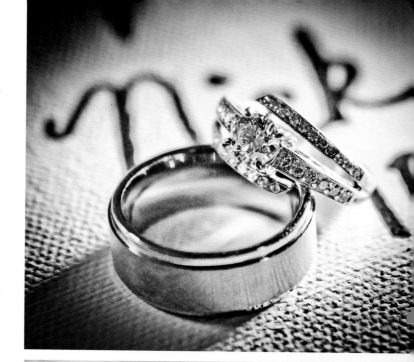

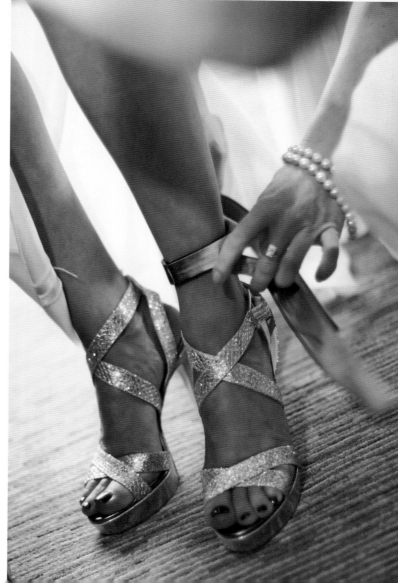

style. One observation my clients make is that the subjects often look happy. Further, they tell me that my upbeat personality is mirrored in the subjects of my photographs. My positive personality is merged into my photography as my clients mirror me. That was a huge revelation that I didn't even realize—but my clients did. It is also a part of my signature style."

Shooting Style

"I always carry two camera bodies when I shoot: a wide-angle setup (like a 24mm prime) and a fast portrait lens (like an 85mm prime), says Scott. "I like to shoot at either low or high angles. This produces

a signature look. For lighting, I use a video light for low-light situations and a flash for bright-light situations. I use a translucent umbrella for diffusing light; it can be set up in seconds for amazing results. I use an off-camera, manual, radio-controlled lighting system to regulate my portable flashes."

Workflow

"I do all my postprocessing. I have been post-processing digital images for fifteen years and have a particular style that is very hard to reproduce," says Scott. He shoots in JPEG mode, then uses Lightroom for culling, cropping, and basic editing. In Photoshop, he creates his signature-style editing. He does all his editing on his laptop.

"My cameras use SD cards and since they are very inexpensive, I never reuse my 16GB cards. I fill them up and then buy new ones. This way, once I copy my images to my laptop, I instantly have two copies of every wedding. I go through the images and pick out the best 100 to 150 images that tell the story of the day and edit those to perfection with my signature style. It usually takes me three to four days.

"I then upload these finished images to an on-line storage site like SmugMug, where my clients can view my finished work. This gives me the added protection

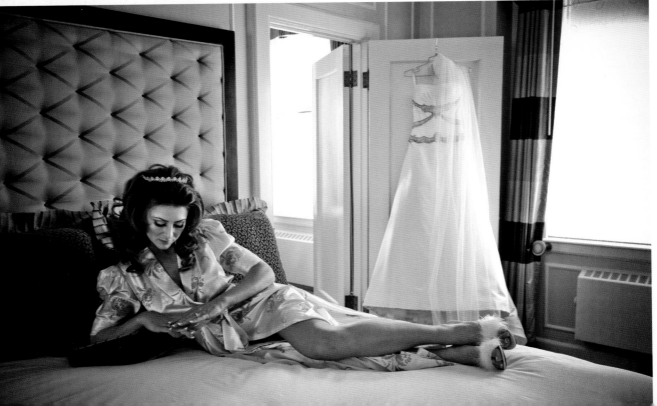

Equipment

Cameras and Lenses—Two Sony A7 (E-mount) or A99 (A-mount) full-frame cameras. 24mm f/2 Carl Zeiss lens; 85mm f/1.4 Carl Zeiss lens; 70-200mm f/2.8 Sony G lens; 24-70mm f/2.8 or 24-70mm f/4 as a backup lens. ("If using my A7, I need LA-EA4 to convert A-mount lenses to E-mount," Scott notes.)

Lighting—Three Strobie 230 flashes (built-in radio receivers); two Tiny Trigger transmitters; two Killer Video Lights; Big Boy Bar and umbrella mount to secure video light and flash on one bar and allows umbrella mounting; two Cheetah stands.; two translucent umbrellas

Power—AA Eneloop batteries (at least two additional sets); extra camera batteries and chargers just in case a re-charge is needed during the reception

Memory—Four 16GB high-speed SD cards ("I usually only need one 16GB card in each camera," says Scott. "I try to average around 1300 images per wedding.")

Backup—Scott notes, "I always have some backup gear that I can use if one of my main items malfunctions."

of having yet another copy of the wedding. I also post the edited images to a Facebook album and tag the people I know." Additionally, Scott copies all the source files from each wedding onto a USB stick drive and sends the unedited pictures to his clients. From the edited images on SmugMug, the clients select their album images—but they can also select images from the source files to be added to the album. "I will, of course, edit these selections if they are not edited," adds Scott.

Key Elements of Success

Glamorizing the Bride. Asked what he perceives to be the key elements of his success, Scott replied, "When my daughter was five years old, we were driving to school one day and she asked me a profound question. 'Daddy,' she asked, 'is it okay that I don't know who I want to marry yet?' It is evident that the bride has been thinking about and planning her wedding from a very early age—perhaps even at five years old! Therefore, I specifically target the bride and try to feature her. A wedding to me is all about the bride.

"Once I started featuring and glamorizing the bride, I noticed a dramatic increase in interest in my wedding business. The more I started to glamorize the bride, the more popular I became and the more money I made. Of course, I always added great images of all the other elements—the groom, bridal party, and family and friends—but it is the bride who is the main feature in my story."

Classic Quality. "My strong commitment to portraiture, lighting, and my signature post-processing style has served me well over the years. I am able to achieve sophisticated lighting techniques anywhere, anytime, and in a very quick and efficient manner. I also pay strict attention to posing. This is the key to making a picture look 'classic.' If you can pose correctly, clients and potential clients will keep returning to your work without visual fatigue; images become timeless and enduring."

Personality. "I have noticed that many successful male photographers are tall and good looking. That's *not* me, so I had to promote and develop other positive attributes that give me an advantage. I am a very positive, energetic, and humorous person with leadership qualities—and I make sure I highlight these qualities when I interact with my clients.

"When photographing a wedding, the photographer is on a job interview—even if he or

Before Weddings . . .

I asked Scott what he was doing before he became a wedding photographer. "I was a graphic designer and small business owner for twelve years before switching to professional photography. These skills helped me tremendously. I had experience with editing photos and postprocessing. I also had a good feel for composition and how to arrange elements within the frame of a camera viewfinder. I made plenty of mistakes trying to start a business, so when I began my photography career, I was able to learn from my mistakes and establish a better business model with my photography.

"Finding the right career is often the blending of many skills and/or passions together. Sometimes this 'right job' doesn't make itself known until we work in the marketplace a while. Eventually, if we search hard enough, take risks, and have a never-give-up attitude, we create a career path that fits our talents and provides an honorable living."

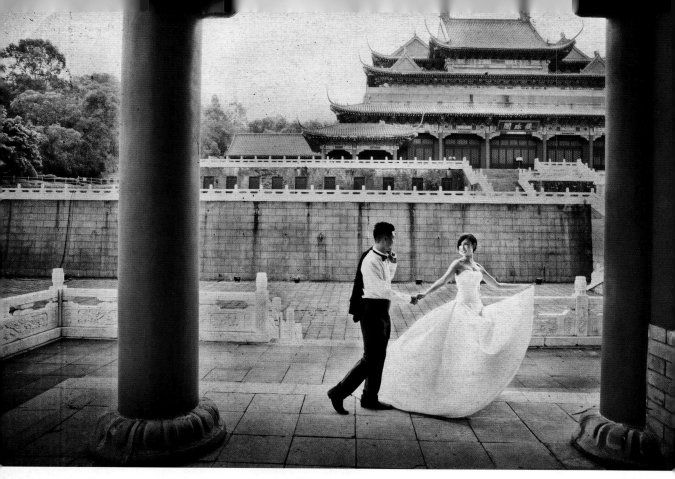

she doesn't realize it. At almost every wedding, potential clients approach me because they like my personality, even when they have not seen *any* of my imagery. This tells you how much personality plays into a person's decision to hire you! Also, the way you are dressed and how your assistants or second photographers represent your brand is very important. Your assistants are an extension of your company, so be careful of the people you choose. Potential wedding clients like to see you in action and imagine you and your assistants at their wedding. Are you professional, kind, courteous, dressed nicely, representing yourself and your studio well? Do you project a positive vibe? New photographers do not realize what a huge role demeanor plays. The photographer's imagery is only half the battle. The way a photographer presents can either be a huge advantage or disadvantage.

Always Learning. "One great thing with photography is that you never feel like you've completely mastered it. Every successful photographer has to not only master current trends but also add to them.

"In the near future, I want to delve into medium format—especially the professional-quality Polaroid. I love the idea of a couple getting a complete set of images fully printed on their wedding day, so they can show their guests wedding images nicely arranged in a large shadow box or frame, ready to hang on their wall immediately! There is a magical feeling shooting a Polaroid print, waiting a minute, peeling back the film cover, and revealing an image. The 'oohs' and 'aahs' are on everyone's lips! The process of shooting these types of all-manual cameras really forces the photographer to slow down and take extra time to craft one shot."

Favorite Techniques

Lighting. One of Scott's favorite techniques involves a video light and a shoot-through umbrella. "In very

low-light situations when I can dial my ISO up to 800–3200 and use a very fast lens, f/2.8 or faster, I use my Killer Video Light with a shoot-through umbrella. I look for an interesting background, usually with many lights, behind my subject.

"I tend to underexpose the background to create contrast and drama, and then I properly expose the subject with my video light shining through the umbrella. I like to bring in the video light as close as I can to the subject, creating the biggest light source possible. Video light is WYSIWYG (what you see is what you get) and it makes it very easy to execute your vision. The umbrella creates a huge light source, especially when three feet or less from the subject.

"Another quick yet effective method of lighting is to use a combination of ambient light and a simple off-camera flash to create backlight and simulate sunlight. I meter the subject as usual in some great natural light, making sure my shutter is within my camera's flash-sync speed. I then add backlight. There is no rule as to the amount of backlight to use—it is all personal taste. I usually position the flash just on the edge of the frame in my camera's viewfinder. The flash is wirelessly triggered by radio waves with my Tiny Triggers, and I manually set my flash according to taste.

"When I add light, I make sure that the nose is always pointing toward the light source and I try to create a short-side shadow to define the cheekbone. If you position the nose toward the light, this creates usable lighting without harsh shadows across the face in inappropriate areas."

> "I make sure that the nose is always pointing toward the light source and I try to create a short-side shadow to define the cheek bone."

Posing. "When I find that a client is hard to pose, I have the subject lean against a wall or pillar with their shoulder or shoulder blade so we can position the shoulder in front of the column and not compress it. I then tell them to pop the hip opposite the shoulder against the wall. This produces a relaxed look. I have

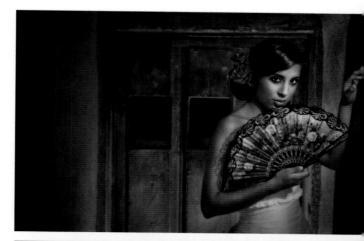

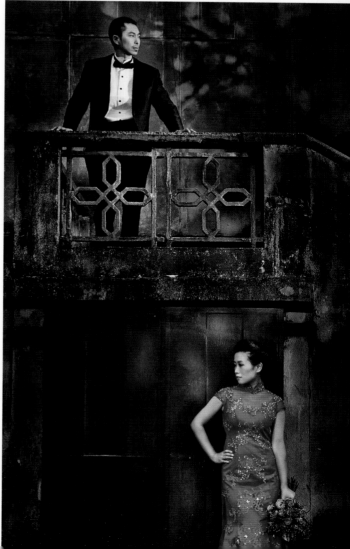

the subject tilt the top of their head slightly toward the popped hip. I create a three-quarter profile, positioning my camera to shoot slightly down on my subject for a very pleasing portrait."

Approach

Resisting stereotypes, Scott considers his main skill set difficult to categorize. "I don't think I can put my wedding photography into a box—but if I had to pick a few words, I would consider my wedding work fashion-forward with a blend of striking candid moments with great attention to progressive lighting techniques. I love to add rich color to my postprocessing style, along with high-contrast black & white images. If possible, I also like to add a few fine-art images where the viewer can't really tell if the image is a photograph or a painting."

"That said, if a wedding photographer wants to be noticed, he or she needs to create a signature style. This is difficult and takes time and experience to cultivate. You cannot simply copy or duplicate existing styles—a signature style is unique and adds to the industry in some significant way. That is why all the great wedding photographers have a passion for their work. Creating a signature style is a labor of love and is only crafted with years of hard work and dedication. Without passion, it is hard to find one's signature style."

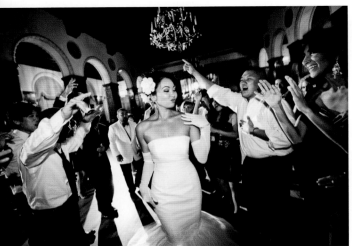

Five Elements of Great Images

Scott notes five qualities of great wedding images. "These elements are enduring and will stand the test of time," he says. "I try to add these elements into every wedding and session that I shoot."

1. **Good Portraiture.** "Executing tried-and-true portrait techniques, yet letting the subject feel comfortable to express their true emotions and reveal their unique character. Trust needs to be established."
2. **Great Lighting.** "When there isn't any great

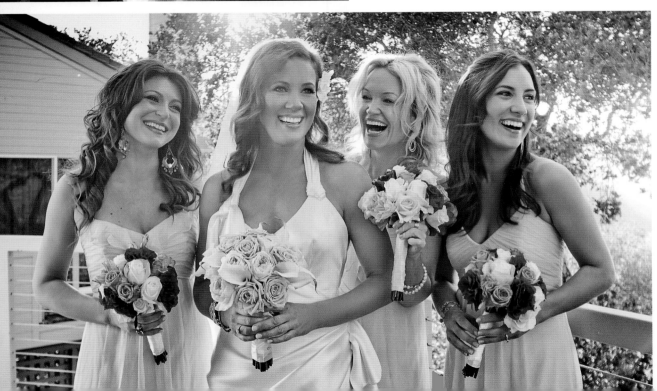

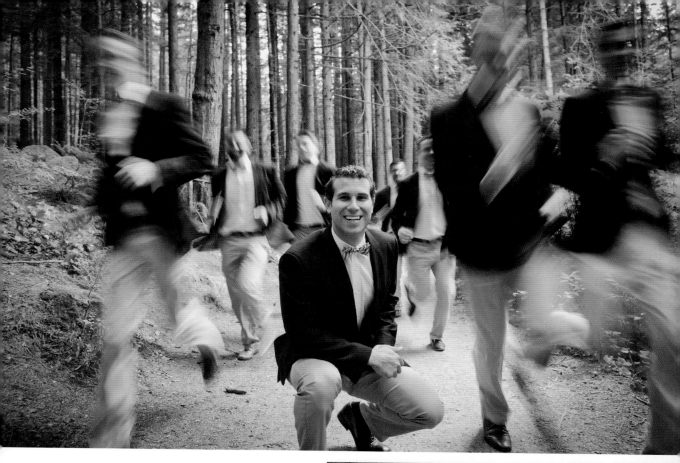

light to be found, I like to create my own light from one to three different light sources."

3. **Point of View.** "Are the elements composed in a visually pleasing and provocative manner? Do the elements tell a story? I often shoot either wide-angle or close-up and like to shoot at extreme angles like on the ground or up above."

4. **Interesting Backgrounds.** "This could either be an exotic location like the Eiffel Tower, on a gondola in Venice, a bride lying down in Times Square, or a background filled with interestingly lit balls of light. No matter where a wedding is, we have to create interesting patterns, shapes, or background elements to compel the viewer to love our photos."

5. **Creativity.** "I try to always add a creative twist to things—whether it is the lighting, pose, composition, angle of the camera, etc. A great photo has an element of surprise to it."

Scott adds, "I always go by these rules—and although I can't accomplish all these elements in every photo, it is what I try to achieve. The more of these elements I successfully incorporate in my images, the better and more compelling the coverage."

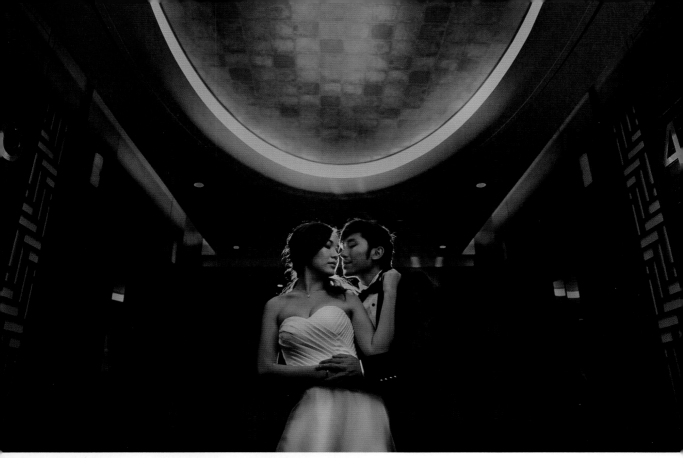

other photographers. However, the most influential photographer and person I tried to model very early in my career was Yervant. He was the first one to show me how to glamorize the bride and add fashion and exquisite postprocessing to my imagery. He showed me the importance of creating a beautifully designed album for your client. He instilled the concept of creating a luxury brand for your studio. Yervant was a guiding light for me and helped me filter through tons of information so I could start to develop my own style and business model."

Influences

Who are those whose style and uniqueness inspire Scott Robert Lim? "There were many influences early in my career—Bob and Dawn Davis, Bambi Cantrell, Joe Buissink, Jerry Ghionis—and from a business point of view, I've respected David Jay and Gary Fong and how they provided services to

What About a Game Plan?

"In the beginning of my career, when shooting a wedding, I ran around wildly shooting like a man possessed," says Scott. "I tried to capture everything and anything. As I gained more experience, I learned to focus on a few shots that embodied my signature imagery yet told the complete story of the day. I try

to capture a story. I magnify the beauty so it can be seen—the emotion, the pageantry.

"When I speak to young wedding photographers I tell them that you only need about fifty shots to tell the story of the day—and that they should not feel the pressure to capture everything. Of course, they need to master all the basic skills, but in essence wedding photography is very easy if you want to do an adequate job. However, it is very difficult if you want to be a master at it.

"The timeline of the day is really the outline you have to work around. Just try to make sure you have as much time as you need for formal portraits, like shots of the bride, groom, bride and groom, bridal party, etc. In regard to the family photos, I ask that they be taken directly after the ceremony and tell my clients to allow three minutes per group shot. Furthermore, they need to make a list of shots they want. This way, the couple knows if the family wants ten group shots, it's going to take thirty minutes.

"In order to satisfy our clients we have to make sure we manage expectations. For example, if the wedding runs late (as a great majority do) and the photographer only gets ten minutes to shoot images of the bride and groom and you requested forty-five minutes, they understand you were not given enough time to execute your signature style. I have developed a set of around twenty shots that I know I can count on that will tell the story of the day and also highlight my signature style. However, to successfully manage these shots, I had to become well versed in portraiture and lighting—and develop a personality that would make my clients confident and relaxed, guaranteeing the best possible wedding-day images."

Ten Years From Now . . .

"Although I want to move backward, mastering some older film and manual camera techniques, I also want to press forward as new technologies emerge. I will continue to pursue destination weddings, but I also have a passion to train and develop world-class photographers. It is very rewarding to help people live their dream life. Having an artistic career is daunting. To be a significant influence on someone aspiring to that dream is truly rewarding. I will also be developing and creating new lighting products. Ten years from now, it would be great to maintain a well respected online retail camera store offering a variety of new and used products with an abundant amount of educational products to inspire photographers using new and old photography equipment to create relevant works of art."

Dan O'Day
A Cinematic Documentarian

Dan O'Day puts everything he has into everything he does, simply because he doesn't know how to do it any other way. He has been the recipient of numerous industry awards, including AIPP Australian Creative Photographer of the Year (2011), the highest scoring print at the 2010 Australian Professional Photography Awards (APPA), the AIPP ACT Wedding and Illustrative Photographer of the Year (2010, 2011), ACT AIPP Professional Photographer of the Year (2010), as well as the Doug Moran Photography Prize. In 2010, *Capture* magazine named Dan one of the Top Five Emerging Wedding Photographers in Australia. He is currently based in Canberra, although a majority of his wedding assignments have him traveling (both domestically and internationally) throughout the year. Dan has exhibited extensively with his fine-art photography, which is held in collections Australia-wide and as far away as London. *(www.danodayphotography.com.au)*

Organizational Abilities

"First of all, I don't have a space that I invite brides to," says Dan. "I share a studio space with two other creatives (with their own separate businesses), and we use that space to help encourage and invite one another into the sometimes desolate world of self-employment. Other than that, I do a lot of my work on the road or in my home office.

"As far as studio management goes, it's myself and one assistant who handles the administrative work (for meetings, scheduling, e-mails) and all the other things that are often too daunting for a creative mind on its own.

"Some studios are structured so that couples visit after a wedding for album sales promotions. Purely as a time saver, I haven't structured my business in this way. My albums are sold before the wedding, or incentives are given after the fact. It's a 'one size fits all' album, so no up-sale is necessary.

"Since I shoot mainly outdoors (and with natural light even indoors), I don't use a studio the way a traditional film/digital photographer might have. The majority of my weddings—in fact, about 95 percent—are clients that live abroad (or not in my region) and require my services via lengthy travel. So most of my meetings these days take place over Skype, a quick phone call, or

sometimes just e-mail correspondence. Still, I don't find this a downfall for social interaction with my clients. In fact, I think it's a huge benefit for my time and work schedule—and my couples seem to enjoy the ease of it as well."

"I share studio space with two other creatives, and we use that space to help encourage and invite one another into the sometimes desolate world of self-employment."

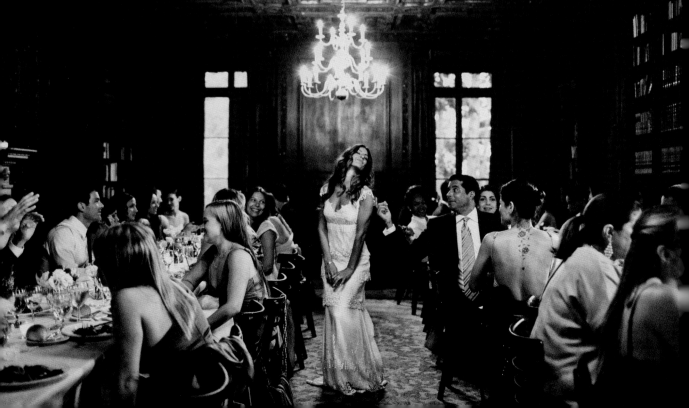

Inspiration and Influences

Cinema, film shorts, and music inspire Dan. He says, "I look at the way I shoot as more of a narrative. Therefore, I am inspired by the branding of cinema (and, as a result, many DVD covers and posters). Oddly enough, although I'm a wedding photographer, my sources of inspiration come from almost everywhere but. I come from an artistic family. I started off as a painter, myself, and moved into fine-art photography. That led to commercial photography, which ultimately led me to wedding photography. I guess I've carried the inspirations for the first fifteen years of my art into my wedding photography.

"For art in general, my father, who is an oil painter and sculptor, was a very powerful influence for my love of craft. As far as fellow photographers go, there are way too many names to list. Annie Leibovitz, James Nachtway, Steven Dupont, Bill Henson, Alec Soth, Tamara Dean, and Gregory Crewdson were the photographers whose work made my jaw drop to the floor. Other inspirations have come from the paintings of Cy Twombley, Gerhart

Richter, and Jean-Michel Basquiat. I also enjoy the colors used by Australian painter Jason Benjamin in his landscapes. On top of that, the colors, cinematic approach, music, and branding of Sigur Rós has had a heavy influence on me in all aspects of my craft.

"Over the years, I've been very careful to shoot what I want, the way I want, and to show only what I want to be hired to shoot. As a result, I've attracted clients who have the same visual taste as I do. And I have been fortunate enough, in most cases, to now be able to have my work sell itself to the clients I want to attract."

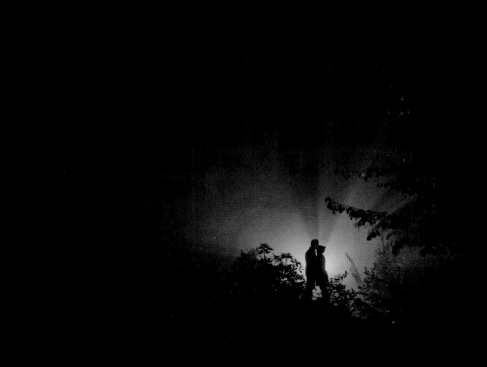

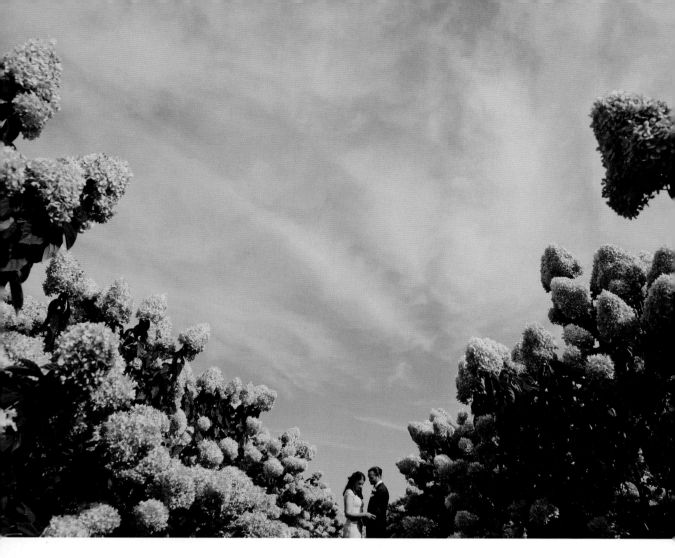

Equipment

Dan shoots with DSLRs for the majority of his wedding work, using mostly 50mm f/1.2 and 24mm f/1.4 lenses. He also uses the Phase One Medium Format IQ250 system for some of the "hero shots" and his wedding portrait work. Dan elaborates, "I use all available, natural light for my shooting. No studio lights. If I'm at a reception, I might put a Speedlight flash on my camera, toward the end of the evening, to blast some light over the dance floor."

"In my studio, I work on two 27-inch iMacs, one 15-inch MacBook Pro, and an Eizo monitor for edits. I ingest and upload my files with Photo Mechanic. I also use this program to make my selects. I edit using Lightroom with presets I've created for myself. For my Phase One files, I edit in the program Capture One." These days, Dan splits the postprocessing workload between himself and his assistant. He says,

> "I've always tried to be aware of what's happening in the market around me, and I made sure that I maintained my own style."

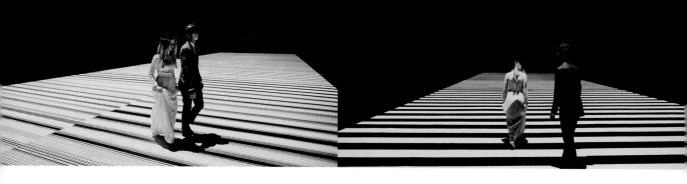

"This hasn't happened quickly—it's required a lot of over-the-shoulder onlooking and my inner control freak calming down. I'm only just now learning to let go. The process, in short, is this: the images are ingested and selected using Photo Mechanic. Once selections have been made, I bring them into Lightroom. From there, all edits are made. Then I export high-resolution JPEGs. Next, a batch-resize is run through Photoshop for blog resizing and client delivery. The same system is utilized with Capture One when editing Phase One files."

Elements of Success

Personal Drive. "I've always wanted to succeed badly enough—I think that's a good starting point,"
says Dan. "I left a well-paying, steady job to pursue photography full time. Not wanting to go back to that lifestyle has been enough of a drive for me never to become complacent—ever! And I work hard never to take for granted the work I get." Dan's other personal philosophies relate to this work ethic: staying alert, never getting lazy, and never failing to challenge himself. "I rarely sit down at a wedding, even if I've been told to. I just can't," he says. "I can't switch off."

Style. "I've always tried to be aware of what's happening in the market around me, and I made sure that I maintained my own style/look in the way that I shoot and process. I think these things have contributed largely to me separating myself from

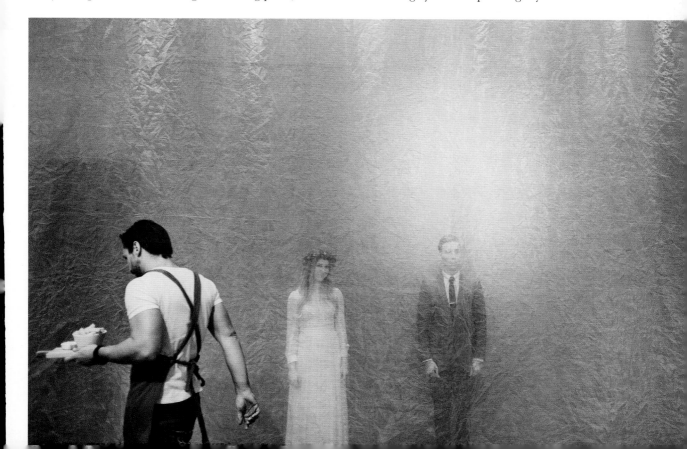

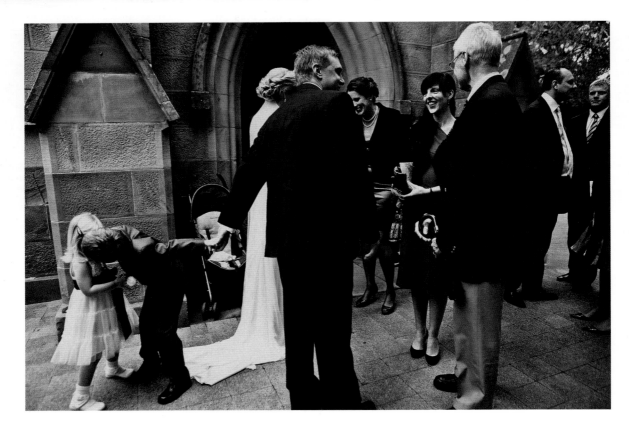

the pack, which has been just enough to attract the clients I needed to succeed."

Community. "Another thing that is often forgotten about is the power of community," says Dan. "I spend a lot of time traveling to industry events, to make sure I'm active in the community, both locally and internationally. It's safe to say that, from that, I receive a lot of referrals from fellow photographers I have met, spent time with, and share a mutual respect for. The power of referrals in the community shouldn't be underestimated. For people to know you exist and help you along, you need to be out there and be active. I'm grateful for the friends

I've made in this business and I feel as though they've helped me out a lot."

A Bit of Fun. He adds, "I also like to think that my sense of humor, and how I interject it into my work, plays a big part in my unique style/brand."

A Standout Blog. Dan views one of the elements of his success to be his blog. Surveying the wedding blogosphere, Dan says, "From an aesthetic point of view, a lot of wedding photography—and wedding-associated blogs—are quite light and bright." Dan has often been told that his work has a certain darker mood to it. There's a cinematic quality in the way that he captures and processes his images.

Favorite Techniques

Dan's favorite photographic technique is unique to say the least. "First of all, there's a system I use when shooting that I call 'Happy + 1 + 1 + 1.' Once I've taken a photo that I'm happy with, that I might potentially walk away from, patting myself on the back, I stop and challenge myself to +1 it. And by that I mean, one-up the frame. Asking myself, 'What

> "Once I've taken a photo I'm happy with, that I might potentially walk away from, patting myself on the back, I stop and challenge myself to +1 it."

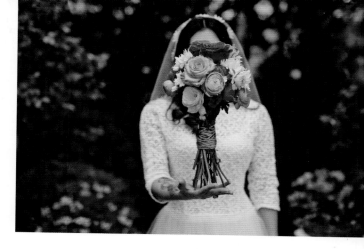

else could I do? What other composition do I want to experiment with? Would it look better if I ran in the opposite direction for 50 meters and got the same frame? What if I laid down and took the same photo?' This opens up a whole bunch of creative windows for me. It forces me to stay on my toes and not become complacent, which is really easy to do in the midst of your busy shooting season. It's easy to get stuck in a creative rut and fall back on poses that you're familiar or comfortable with, and that you know will work. But as soon as you get comfortable shooting the same thing over and over, you run the risk of losing the fire in your belly or the excitement you need to advance yourself as a creative.

"I try to fit as much story as I can into one frame when shooting my documentary style (hence my use of wide lenses like the 24mm). I'm always on the lookout for two or three different stories happening in sequence. This, for me, makes an interesting frame. I guess you could say that moments like this in my portfolio are inspired by lots of historical photojournalistic photography that I've admired."

Another creative approach Dan often uses is metering to the brightest part of the room or subject. "This gives my images an overall darker/moodier feel," he says. "That's a personal preference that I've held since the beginning that has grown into what people have recognized my work for."

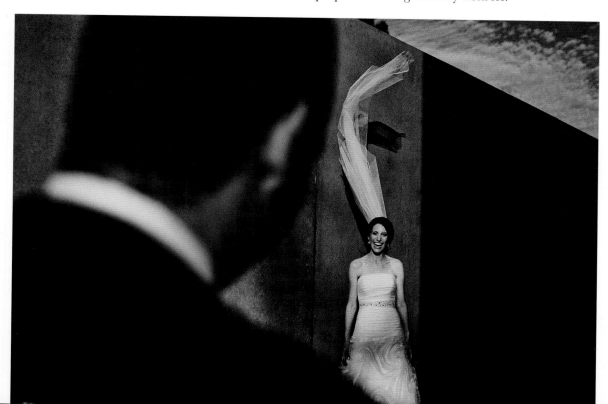

Dan's Approach

Asked what type of photographer Dan sees himself as, he responds, "When I first started, I was more interested in the location shoot and making the

location shoot as fine-art influenced as possible. At the time, that worked for me in my local market. It helped me stand out from my competitors because I was drawing influences from the art world instead of the wedding world. Over time, however, I have become less and less interested in the location shoot and more intrigued with documenting and delivering a visual narrative as much as I can from a wedding. To me, that's more of a challenge, and that's where my interests lie now. So 'journalistic' would be my preferred label and where I'm trying to put all my energy these days.

"I also try to instill my personality into a lot of what I do. It's in my brand, in the way I shoot, and what I deliver as a product. At the end of the day, we can all have the same postproduction actions, website templates, and editing techniques—but what will carry us in this industry is our individuality. Working out what that is and using it to sell your product is a valuable niche to find yourself in," says Dan.

A Second Shooter

"I always work with a second shooter—for many reasons, some of which are backup equipment, multiple perspectives, having assistance throughout the location shoot, and having someone to talk to for the duration of the day," says Dan. "Also, there are all the other obvious things, like having enough cards, having them cleared and backed up from the previous weekend—and, always, location scouting before a wedding. There's nothing worse than walking away from a shoot thinking, 'I wish I had more time in this spot to execute an idea that came to me an hour after leaving it!'"

The Ultimate Responsibilty

"I think it is very easy—especially amidst a busy wedding season—to take lightly the responsibility that we've been given as wedding photographers," says Dan. "It's important to remember that we've been invited into these people's lives to document, in most cases, the most important day they've had yet. I think I and other photographers have been guilty on occasion of taking this responsibility for granted and also getting our priorities confused. Are we shooting to impress other photographers or to make our clients

In Ten Years

Asked what he wants to be doing in ten years' time, Dan joked, "I'd like to think that I might have made some babies by then – in which case I wouldn't like to have the shooting schedule that I currently hold. With the work I do these days, I'm away from home the majority of the year, so much so that I can't even have a dog. I can see myself potentially still shooting weddings in ten years, but maybe a lot fewer of them. With a partner, I've recently started up a photography agency that represents seven photographers. If all goes well, hopefully that will allow me to have my weekends back in the next five years – by cutting my workload down to ten to fifteen weddings a year.

"Ultimately, I'd love to stay in the arts with whatever I do. I'd like to continue to have a gallery show at least once a year of my fine-art photography. And I'd like to explore more avenues, possibly even a book! I'll never stop taking photographs, I know that, but I'm excited to explore different mediums and avenues to make more art as I grow older."

happy? First and foremost are the clients that pay our bills—it's the clients we need to keep happy. The amount of 'likes' on a photograph isn't money in the bank. A priority check in this quickly changing industry is essential. So I guess my philosophy could be summed up into, 'Do right by your clients while still staying true to your vision.' It's a fast-paced industry, so you can't really afford to drop the ball."

Danny & Julia Dong
An Anatomy of Style

Danny and Julia Dong are a husband-and-wife team who live and work in the Silicon Valley area of Northern California. Danny specializes in what he calls the "stylized, unconventional wedding portrait" but still embraces the tradition of wedding photojournalism and capturing moments and emotions. Danny has taught workshops for WPPI (Wedding and Portrait Photographers International) and his Asian workshop is rated as one of the most popular wedding photography workshops on that continent. Complementing Danny's style, Julia's photography combines intuition and a unique fabric of artistic sensibilities. In addition to serving as a judge for the WPPI filmmaking competition and 16x20 print competition, Julia has been invited by numerous professional photography organizations to speak and share her photographic vision and skills through international seminars and workshops. *(www.dannydong.com)*

While earning an MBA from University of California Irvine, Danny managed to take a number of courses in the school's Visual Arts department and spent hours in the darkroom, perfecting burning and dodging techniques, testing different contrast ratios, and understanding image density and exposure. This practice prepared him to adapt to digital and postproduction techniques. Prior to becoming a wedding photographer, he also spent ten years as a painter—mastering the intricacies of Chinese painting that led him to appreciate the post-processing phase of wedding photography.

Danny's MBA has also helped immeasurably in the running of the couple's business. As Danny puts it, "Instead of becoming a CEO to manage a big company, I became a CEO of my own photography

company." Although Danny values his business-management education, he believes the secret to business success comes not from a book or a class, but from experience—from test and trial.

Complementary Styles

Julia, a software engineer for a semiconductor company in Silicon Valley, accompanied Danny to cover her first wedding assignment in 2008. From the moment she witnessed the father-of-the-bride's tears of joy, Julia instantly knew that this was her passion, as well. She shot with Danny for three years before she quit her job.

During that time, she worked at least forty hours a week and would additionally shoot with Danny almost every weekend—for every single wedding and engagement photo session. Danny says, "I don't know how she did it. Photography needs talent. But besides talent, she is hard-working for her passion.

If we only shot ten weddings a year—that's fun, that's interesting. But covering *forty* weddings a year requires much more than passion and interest. It's dedication—a dedication to delivering high-quality work and a dedication to doing better and better for each project."

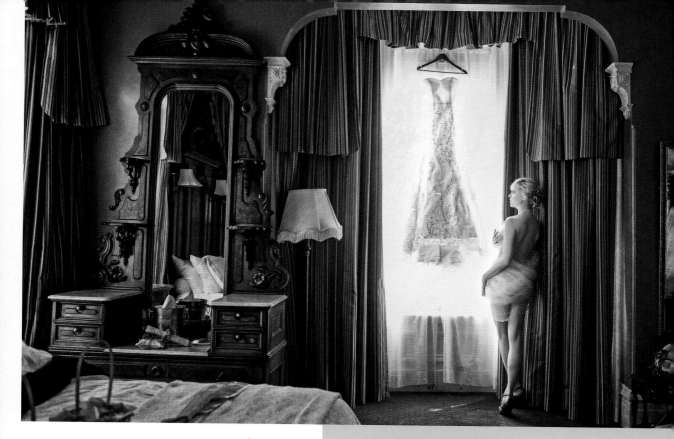

Inspiration

Danny says, "Anything visual can inspire me. We live in a world that is now overwhelmed by imagery. We are exposed to visuals through all types of media: Facebook, the Internet, movies, television, etc." Whenever he sees something that is visually stimulating, he'll ask himself how it was made. What's unique about it? What impressed him most? Julia thinks he's crazy when he watches a movie in the theater and makes comments like, "Look at the beautiful lighting—it's short light (or it's backlight, etc.)." Says Danny, "She thinks I am way too much into the technical details and not really watching the story of the movie."

The Pitch

Danny and Julia pitch their style of weddings as a combination of wedding photojournalism and stylish wedding portraiture. They let their photos sell themselves—but that's not always as easy as it sounds. In today's market, couples are exposed to

An Ideal Partnership

Julia's approach to wedding photojournalism is sensual and uniquely feminine. She also possesses an impeccable attention to detail that allows her to seize every intimate moment at the precise time and perfect angle. Moreover, Julia's natural empathy for people helps her capture her subjects in a truly candid and organic style.

Danny sometimes feels spoiled to have Julia covering weddings with him (the image below shows them shooting together). He eventually wondered if he could even do it without her–and Julia wondered the same thing. So, because the couple challenges themselves daily, they have now begun to shoot separately. They charge the same rate but they have different styles and attract a different clientele. The boudoir image above is of a fifty-year-old bride photographed by Julia.

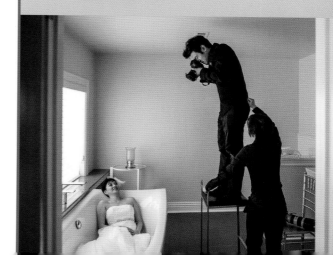

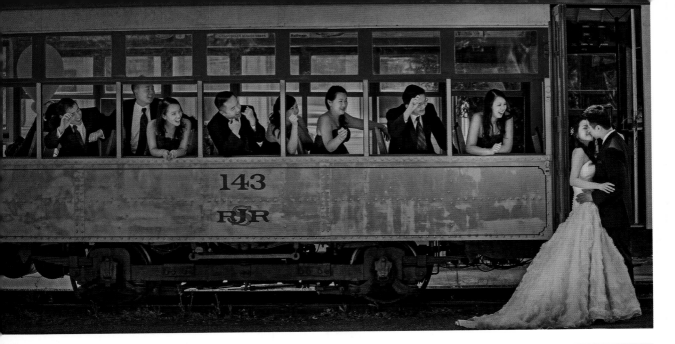

Workspace

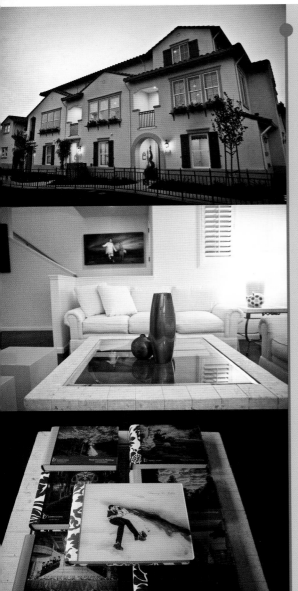

In 2009, Danny and Julia Dong bought a three-story townhouse in Silicon Valley to use as a home studio (*top, left*). They think it's the most time- and cost-efficient approach to running a boutique wedding photography studio. They do not have to pay rent, nor do they need to drive to meet clients. They use the second-floor living room as the conference room to meet with clients during their initial consultation, for a second meeting (two weeks before the wedding) to walk through the timeline, and for the album-planning meeting six weeks after the wedding (*center, left*). They use one of the bedrooms on the third floor as their office for postprocessing. The couple does almost all of their shooting on location – but, every once in a while, Danny will convert the garage to a studio setup for some commercial projects.

The couple finds that having a home studio plays a vital role in their business. It creates a cozy and relaxed environment for consultations. That makes it easier to build trust – and it gives couples a sense that there is a place where they can get in touch with the photographers. Additionally, the environment reflects the photographers' artistic taste and quality of life. When couples visit, they are observing Danny and Julia's images (*bottom, left*), but also how they've decorated the house – what furniture they have, for example – to evaluate their style, taste, and station in life. Couples tend to seek out and like people who share their tastes.

Danny and Julia also note that the location of the home studio matters. The Dong's townhouse is in the city of Milpitas, about fifteen miles from the center of Silicon Valley. Since most of their potential clients live within a thirty-mile range, it is easy for them to come for a weekday-evening meeting.

Having a home studio and consultation area also forces Danny and Julia to clean the house constantly and keep it ready for clients to come over. It should always look business-like and presentable.

a lot of great images, and many people are visually exhausted from seeing so many images posted on social networks. Therefore, Danny says, "In our work, we emphasize 'wow' effects first." This can be achieved by any number of means—it can be the story, the concept, the technical details (such as lighting and color)—but, overall, the image needs to demand attention and make them remember the photographers.

Once a bride and groom are drawn in by the images on the Dongs' website or Facebook page, they schedule a studio visit and consultation. However, according to Danny, that's not enough. The sale is not done yet. The couple might also visit other studios. They might also like other photographers' work. That makes it critical, during the consultation, to educate the couples about wedding photography and finalize the deal.

For this, the team has a unique sales pitch. Danny and Julia will analyze different styles in the contemporary market and help the engaged couple discover what photography styles they are really

Time Management

On average, Danny and Julia will be shooting around sixty days/sessions a year—about forty weddings and twenty pre-wedding and engagement sessions. The rest of time, they work out of their home studio. For each wedding/couple, they spend about forty hours. The following is a rough breakdown by project and function:

- Two hours for e-mail communication
- One-hour consultation
- One-hour meeting to go through the couple's timeline
- One-hour album-planning meeting after the wedding
- On average, ten hours of wedding-day shooting
- About three days of postproduction time. This includes backing up data, image selection, postprocessing, album design, album revisions, file submission to the album company, ordering canvas, etc.

The busy couple forces themselves to take one day off per week so they can relax. Normally, that day will be Julia's shopping day and Danny's movie day. In 2012, according to Danny, they worked way too hard and got stressed out. In 2013, they set up this rule to force themselves to find a better balance between work and life.

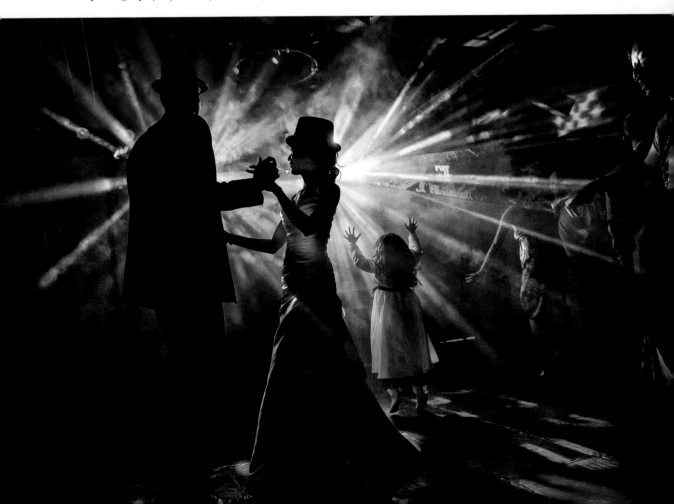

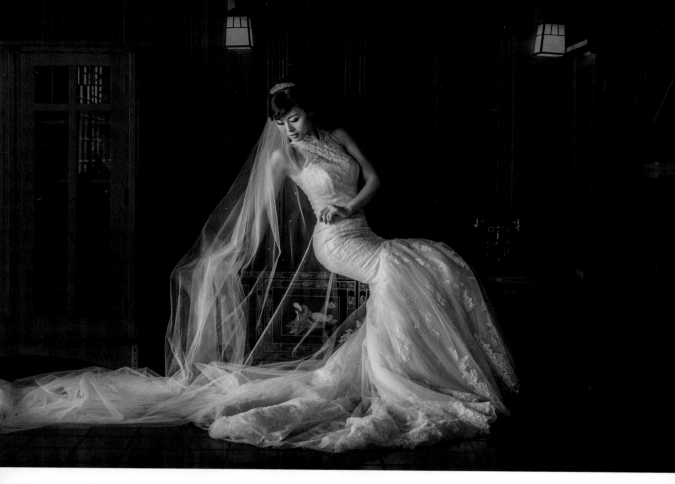

looking for. Many couples don't even think about this before Danny and Julia bring up the topic.

This discussion helps them understand what Danny and Julia are focusing on—and whether or not this is a good match. After the discussion, he'll sometimes find out they are looking for 100 percent photojournalism—no directing or posing during the shooting and no postprocessing at all. Danny says, "I can try to shoot like that, but I would rather refer them to another photographer that better matches their style rather than convincing them to book us. While we try to get bookings, we are also selecting the right type of customers to make sure there is a happy ending for each side."

Equipment and Software

Danny has been shooting with Canon cameras for the past ten years (although he recently received his order for a Nikon D4S, his first Nikon camera).

Five years ago, his preferred rig was the 5D Mark II and Canon 85mm f/1.2 II and a second 5D Mark II and a Canon 35mm f/1.4 lens. He used these cameras and two lenses for the majority of his wedding coverage. Since Canon released the second generation 70–210mm f/2.8 II and the 24–70mm f/2.8 II, Danny says he has used his prime lenses less often. Danny cites the improved ISO rendering

> "While we try to get bookings, we are also selecting the right type of customers to make sure there is a happy ending for each side."

and the improved sharpness of their zoom lenses for the switch. Although Danny describes himself as a camera nut, he is the first one to admit that it's not the camera itself that makes the difference—it's the brain behind the camera.

Julia and Danny both use iMacs for image processing. Lightroom and Photoshop are the main programs they use to process their images. They also use Nik software for black & white image conversion and HDR (high dynamic range) processing. For album design, the couple uses Adobe InDesign.

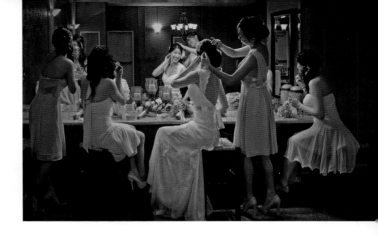

Postprocessing

Julia and Danny do 100 percent of the post-processing themselves. Even though it is extremely time-consuming and occasionally boring, according to Danny, they think that it's an important element that makes their work unique and makes them stand out from other photographers. They believe that shooting is only half of the photography; post-processing is the other half and a second opportunity for "re-creation."

The couple also continues to develop their post-processing skill set. Software updates occur often, and they generally greatly improve the program's performance and speed. So every year, from January to March, they do research and watch tutorials online to improve their images and workflow.

Danny and Julia shoot in the RAW format and then convert their RAW files in Lightroom to do basic adjustments, like exposure, color temperature, shadow and highlight adjustment, noise reduction, lens-distortion correction, etc. Then the image is

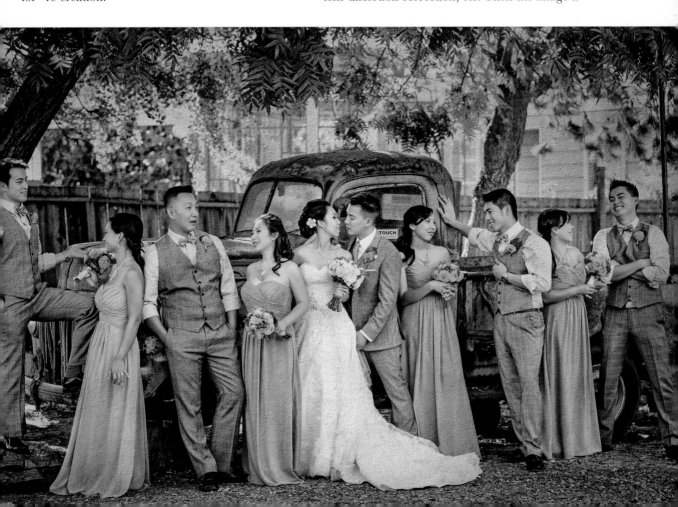

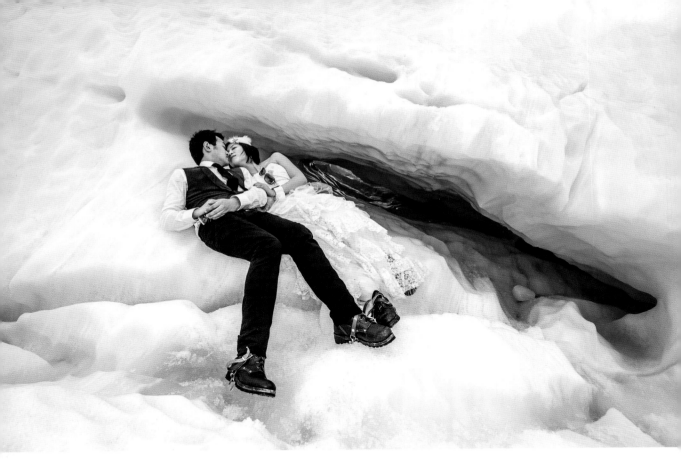

opened in Photoshop for detailed adjustment by adding adjustment layers, dodging and burning, fine-tuning the color, retouching the skin, etc.

Image Qualities

Uniqueness is one of the qualities Danny and Julia strive for in their images. People only remember unique images. Every time the pair shoots a wedding, they are trying to get at least a few unique, unforgettable images that will make the couple remember their wedding day fondly. It is difficult to define what makes an image unique, but it could be

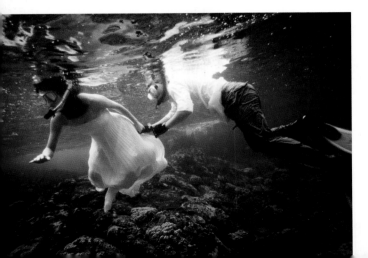

a unique location or a unique concept. It could be a camera angle that is different or an unusual lens choice. It could be beautiful lighting or dramatic backlighting that makes the image memorable. It could be a unique postprocessing approach.

Danny says, "When we wrap up a wedding and are ready to post on our blog, we will start to question ourselves. Have we got some unique shots of this wedding? Can this blog post differentiate our work from other photographers' weddings at this venue? Does this wedding look the same or different from our other weddings?"

Photographers are artists—and artists, by necessity, need to have a unique style. Style is what separates good photographers from great photographers and it is what differentiates photographers from one another. Danny likens style to fashion design. "I can buy a shirt at Costco for $30, but I can also buy a shirt that might cost me ten times more at Armani. Why would I spend ten times

more to buy the Armani shirt and still feel happy about it? It has a unique style. The style makes me think it can make *me* look different—look fabulous. If I try to convince a couple to spend twice or three times or five times the average market price to book us, I have to make them believe that our photography has a style that can make them look charming and fabulous."

Evolution of Style

A good reason why many photographers don't succeed in the long term is that they don't allow for their style to evolve to a new and higher level. In 2008 and 2009, most of Danny and Julia's clients remember their work by the use of bold color and the element of fun—a couple jumping into the air with happy smiling faces or a bride snorkeling in her wedding dress, for example (*facing page*). Danny comments, "Now I feel these images are kind of cheesy, but I still love them. They reflect my personality and they attracted many young couples

who love outdoor activities. They still attract clients who want to fly us to Hawaii to shoot a trash-the-dress session or drive to Lake Tahoe for an engagement photo shoot."

A seminal moment in Danny's stylistic evolution was his 2010 trip to the WPPI convention. "I was shocked and greatly inspired by the many amazing speakers, especially some wedding photographers

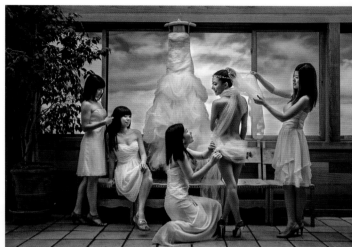

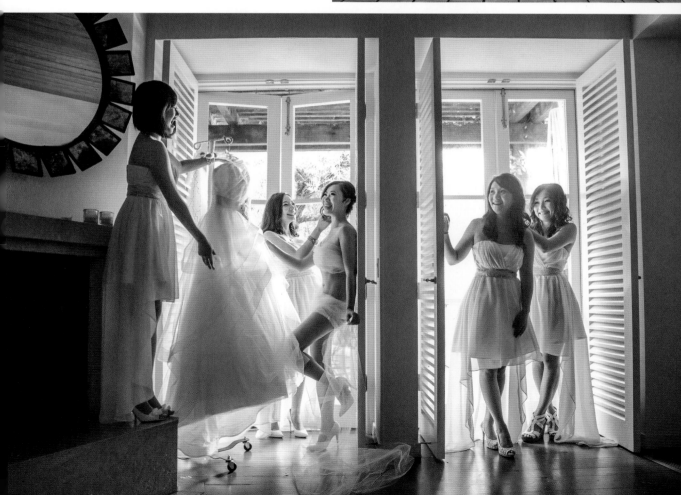

from Australia—Jerry Ghionis, Yervant, Rocco Ancoro, and Ryan Schembri, to name a few. Their work is so stylized, with a sense of fashion and glamour. From that time, I realized how much I needed to improve my technique."

Something that really helped Danny and Julia in this evolution was entering images in international print competitions. Gradually, they started to learn what type of images were highly regarded by industry professionals rather than just their own clients. Danny says, "I also started to realize that good images need stories. A good wedding photographer needs to be a good storyteller. So I started to test and create the storytelling wedding portrait." Attending WPPI's 16x20 print competition every year has also helped Danny maintain a good perspective on his own work in relation to trends among other industry leaders. "The purpose of entering the contest is not to win—it is to see other photographers' best work of the year and see the difference," he says. "All the world-famous masters such as Jerry Ghionis, Bambi Cantrell, and Cliff Mautner are still entering competitions. They, too, are evolving and analyzing new imaging trends and styles. Even though they are acknowledged masters, they realize the importance of not becoming stagnant and re-inventing themselves when needed."

Favorite Techniques

Danny likes to use reflective surfaces to add some interesting visual elements to his photographs. He also uses them to help eliminate unwanted information. For instance, he might use the reflection from a table to cut all the information on the ground, such as chairs, shoes, etc. (*below*).

Another favored technique of the team these days is off-camera backlit flash (*facing page, top*). Off-camera lighting skills are not easy to master—

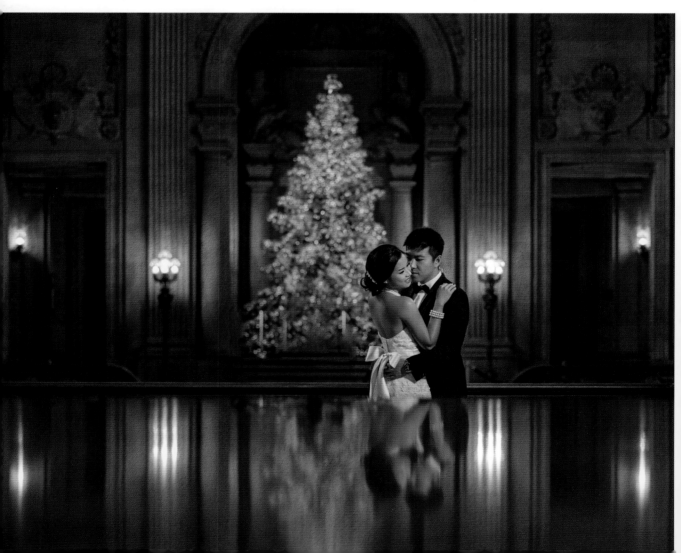

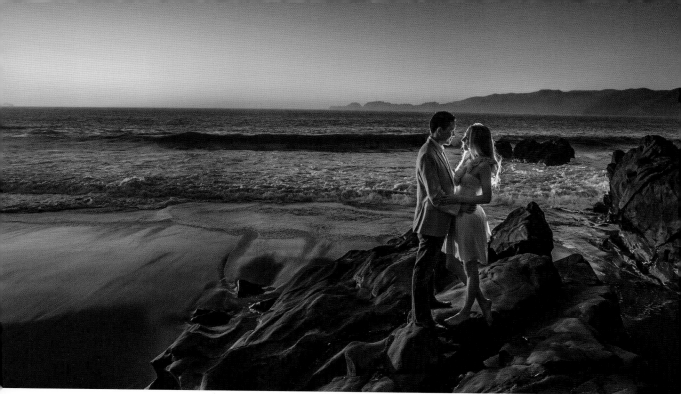

especially for wedding photography, when there is so
little time for experimentation. Knowing the exact
flash output and the optimal distance between the
flash and the subject for each new image requires lots
of practice. So when Julia and Danny have a chance,
they use themselves as test subjects. Says Danny, "We
never waste time on our clients' wedding day."

Framing the subject (*right*) is a traditional
technique used by wedding photographers. Says
Danny, "We like to use the mirror in the room to
make interesting storytelling images."

Why Wedding Photography?

"The reason I choose to be a wedding
photographer," says Danny, "is because I believe
wedding photography requires a very comprehensive
skill set. To be a great wedding photographer,
one needs to be a great photojournalist to capture
fleeting moments, a great portrait photographer to
make people look good and reveal character, a great
landscape photographer to capture the wedding
venue and the beautiful environmental portrait,
a great commercial photographer to shoot all the

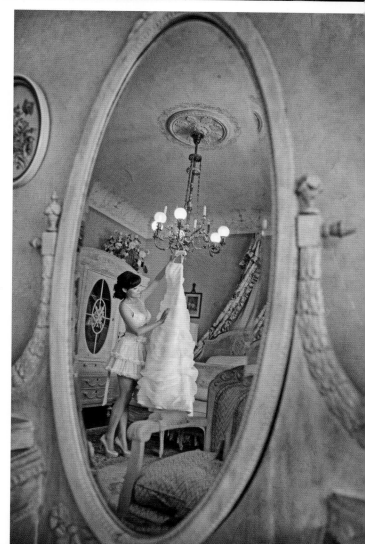

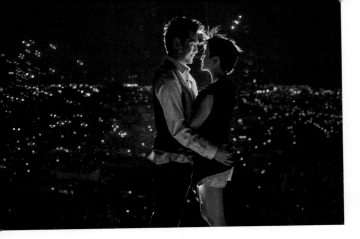

sometimes practice posing themselves for self-portraits. "If we feel awkward in a pose, we won't use it with our clients," says Danny. "When I give posing directions, the most efficient way is just showing the bride what I want. Our brides always think it's so funny and that they can do a better job than me. I sacrifice myself to inspire them," he says, laughing.

Game Plan

One final piece of advice from Danny concerns having a game plan for the big day. He always visits the venue a day or so before the event. He recalls, "I did a site visit before covering a wedding at the Asian Art Museum in San Francisco. It is a huge building with very high ceilings. I knew if I wanted to get one venue shot to showcase the entire setup, I needed to bring my 14mm wide-angle lens." The steps and the ballroom reminded Danny of a scene in *Beauty and Beast,* where the Prince leads Belle to the ballroom and starts to dance. "So I tried to re-create the movie scene in this wedding venue. About five minutes

wedding details, a fashion photographer to make ordinary people look like superstars on their wedding day, etc. And to succeed, a wedding photographer also needs to be innovative and creative—sometimes even bold and fearless—to break the long-standing conventions and traditions."

Posing

Danny and Julia's posing techniques help the subjects relax and feel comfortable about the portrait. They

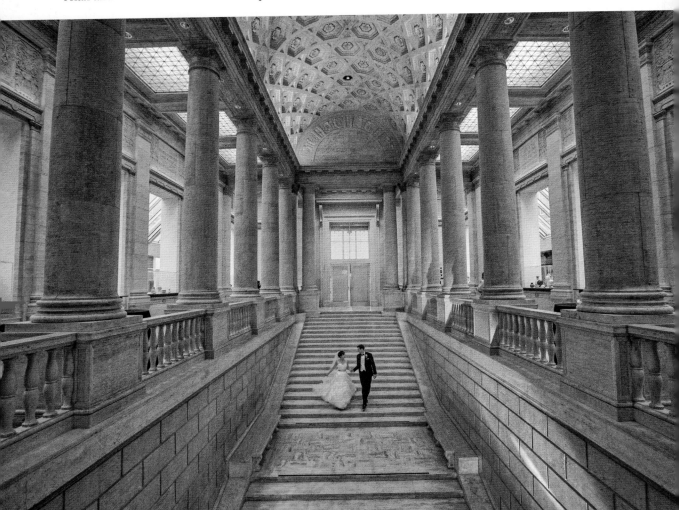

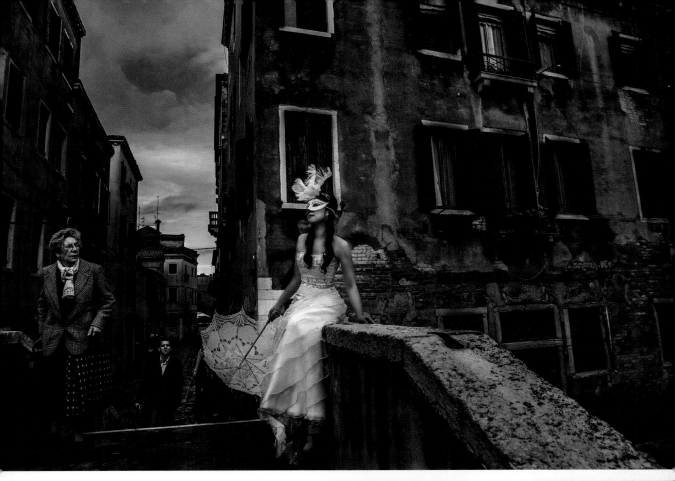

before guests were allowed into the ballroom, I talked with the venue coordinator and showed her the fisheye image on my camera screen. She had never seen a shot like this, so she was very excited. Then I said, 'Can you do me a favor and ask all the service people to leave the ballroom for just two minutes? I want to bring the bride and groom here to take a look at the beautiful setup and rehearse their first dance.' The resulting image was the couple's choice for their wedding album cover and is displayed at the Asian Art Museum (*facing page, bottom*).

The Next Ten Years

Seven years into his career in wedding photography, Danny says, "For the next ten years or so, I think we will still be enjoying the life of wedding photographers. We are passionate about this career and hope to keep building a solid foundation and customer base. In ten years, we hope we can build

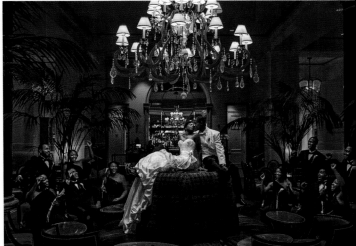

our brand as one of the most prestigious names in wedding photography. And maybe after ten years accumulation of experience and knowledge, we can start sharing and teaching."

Jose Villa
Fashion-Forward Fine Art

Jose Villa is a fine-art wedding photographer whose images are as unique as the people he photographs. His award-winning images have appeared in prestigious publications around the world, including *Grace Ormonde Wedding Style*, *Elegant Bride*, *Instyle Weddings*, *Inside Weddings*, *Brides Magazine*, *Modern Bride*, *Martha Stewart Weddings*, *Pacific Weddings*, *Southern Weddings*, and many more. *American Photo* magazine named Jose one of the world's top ten wedding photographers. His sponsors include FujiFilm, Cypress Albums, Richard Photo Lab, and Triple Scoop Music. He is also the creator of the acclaimed Jose Villa Workshops, where he shares his expertise with wedding photographers at exotic locations around the world. (*www.josevilla.com, www.josevillaworkshops.com*)

Due to time constraints, and Jose Villa's insane travel schedule, we decided to do a phone interview instead of him writing out answers to the fourteen questions I sent him. When I read over the transcript, I liked the natural flow and the abundance of information that I knew would be useful to readers. Therefore, I decided to keep the interview in the question-and-answer format.

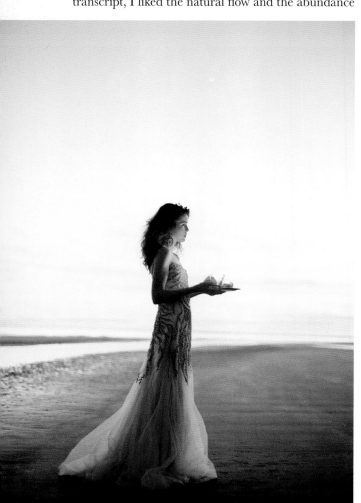

Bill Hurter: How is your studio organized?

Jose Villa: First of all, I work out of my home. I used to have a studio. My home setup is pretty simple. The reason I purchased this home is because the setup of the home is really nice. My studio is upstairs. I call it my studio/office, but it is really my office. I don't necessarily shoot in my office. I mostly meet people here because all my work is done outside the office.

When a client comes by, you don't have to go through the bedrooms or the kitchen or anything like that. When you open the front door, you first see the living room, which is a very homey little area. Most of my clients tend to gravitate toward that room, so when we first meet them we might just sit down there and chat a little bit before I introduce them to the upstairs office. Up the staircase, there are huge photos on the left and on the right. I had beautiful custom frames made for the large photos, which are 40x60 inches. At the top of the staircase is another 40x60-inch image, a vertical, and it is what I would say is a very identifiable Jose Villa photo that's been out there for the last couple of years and brides kind

> "I know some photographers like smaller framed images, but I wanted huge images that have great impact."

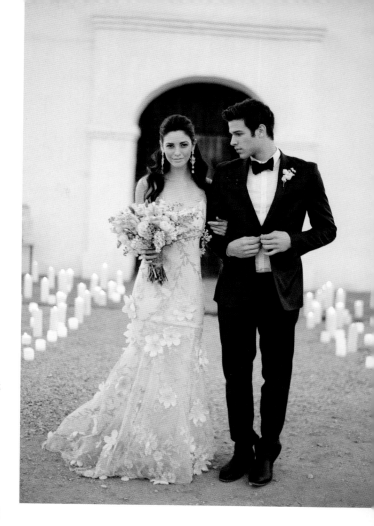

of get excited when they see it. Brides see the image and say, "Wow, I've seen this picture somewhere—I can't believe it!"

If you continue down the hallway there are more 40x60-inch images. I wanted to go big. I know some photographers like smaller framed images, but I wanted huge images that have great impact. They get the conversations going and they get people excited.

When we designed the office, we wanted people to feel like they were looking at my website. When I first moved here, I had a couple come and meet me here—young clients. This was about seven years ago. We said hello, and I noticed they were holding hands and looking at each other and smiling and smirking. I always watch very closely what my clients are doing. The bride suddenly looked at me and she took a deep breath and said, "Oh, my gosh, I feel like I'm sitting in your website." I never really thought about it like

that before, but when she said that, I thought, "Okay, bingo. This is it." It totally made sense. It was exactly how I envisioned this place. Sure enough, of course, they booked me and it was exciting. I thought,

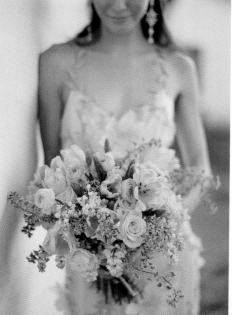

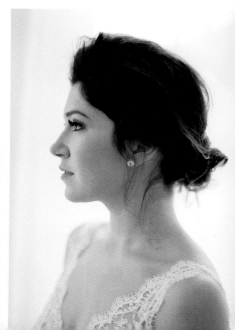

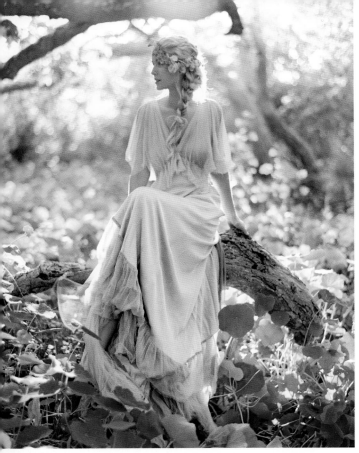

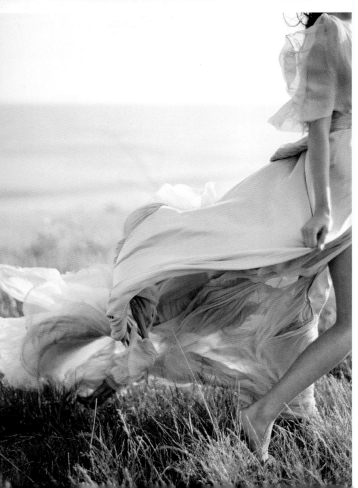

"Wow. That's such a strong thing for photographers to do." I started learning from that experience.

Other things I did to make my office/studio more client-friendly include: soft colors on the walls, hand-printed fine-art images, a lot of light via skylights, three hand-done beautiful desks, and things like that. I used to have a chandelier, which I liked very much. It made the room a little bit more soft and feminine, but I didn't want to make it too feminine. Of course, I wanted the room to have a feminine character, and of course I want to sell to these brides, but because I'm a male photographer, I didn't want it to be too feminine.

Of the three desks, one of them is mine and then I have two employees that work in the outer office. I have another office that is a smaller one that we've expanded. No clients go in there—it's more of an editing room. I have a total of three employees.

BH: You're a film shooter. How do you organize differently than all-digital studios?

JV: Because I am a film shooter I don't have a ton of hard drives. Because we live in a digital world, we have all of our negatives scanned. They are scanned at high resolution—or at least what we consider high resolution, which is 11x14 inches. Some photographers say that's medium but we say it is high res.

The way that we archive, and the way that we organize, is that we start with the master negative. That's one way of archiving and just always referring back to the film. Then, we have a master DVD that we get from my photo lab, Richard Photo Lab in Los Angeles. Then, from there, we make two copies

"When we designed the office, we wanted people to feel like they were looking at my website."

onto a hard drive—one onto the master hard drive and one onto that computer's hard drive. So we have a master hard drive for the whole studio, which everything goes onto. And then, each computer has its own copy of it as well. We have basically four ways of backing up, and that's the way that we organize these negatives. Now, the negatives themselves are in binders and they're all sleeved.

Because of the design elements of the studio, we wanted all the binders to be white. So the binders go onto this beautiful shelf. They're all white and they're all labeled with the couple's last name and the date so they're easy to find.

If we have to refer back to the original negative, then every negative has a twin-check number—and, of course, a frame number. So if a client wants a larger image, maybe a 16x20-, or a 20x24-, or a 40x60-inch print, then we refer back to the original negative and get that drum-scanned to be able to print it large enough.

BH: What's a "twin-check" number?
JV: A twin-check number is actually something that photo labs use in order to keep the negatives in order. For example, one roll number may be 1234. It's usually a four-digit number. Then there's a frame number on each roll.

I'm very old school. I like to get everything printed, and so every wedding image has to have an actual proof. That proof has the twin-check number on the back. So if my client wants to get a reprint, they look at the back of the actual printed image. We find the roll. And then, of course, there's the frame number on the back of the image so that we can find it on that specific roll. The twin-check number really is just one way for us to identify the roll and one way for the lab as well to identify the roll when they're processing and developing it.

BH: Don't you use an archiving program or website?
JV: I don't use any programs like ShootQ for the back-end business part. I don't use Pictage, either. I don't use any of those—not that I have anything

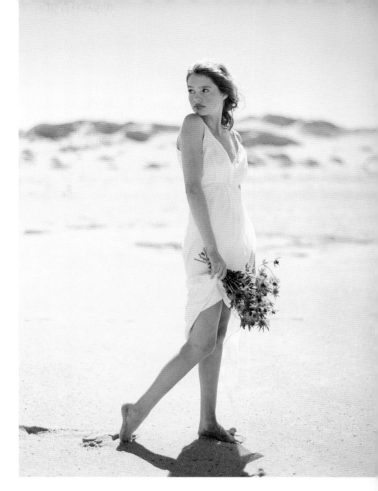

against them. As a film shooter, I'm a crazy minimalist, so I don't like to use a lot of things that complicate my life. We're not in the business to sell reprints. I'm in the business of photographing the highest-quality images for very high-end clients. I charge premium prices for shooting. I don't necessarily charge a premium for negatives or, let's say, reprints.

BH: What are your sources of inspiration? How do you fuel your creativity?
JV: I'm very much into travel. I like to step outside of what I'm normally used to. I started to realize how much I love travel when I started to get these big destination weddings. I would go over a few days early or stay a few days later to explore the area. We're so fortunate to be able to travel to these locations. As the wedding photographer, of course, all the expenses are paid for. Really, I've become

inspired by the different locations and the culture and the beauty. So a big part of my inspiration is getting to appreciate different parts of the world.

I love color. I tend to work in softer pastel colors as my palette. I recall my first trip to Cuba with the amazing, brightly colored cars from the 1950s. I decided to go back on my own two years later. I'm very inspired by things like that.

People also inspire me. I like to make sure that I connect with a client. I'm very much into people's responses. If people are into what I'm doing photographically, it takes my photography to the next level. Of course, it also depends on the couples or models with whom I am working.

BH: When you work with models, are the images for your promotional purposes?
JV: The models I work with I would do for my portfolio—and I photograph models for editorial spreads, magazine covers, and other features, as well. I also work very closely with some of the dress designers. Of course, we're using professional models for things like that.

BH: Some of the girls you photograph are just exquisite. Incredibly beautiful.
JV: The images I sent you are mostly actual couples. I do attract beautiful couples and that's because, in the beginning, I would show beautiful couples. I started to realize that I was attracting other beautiful couples by photographing beautiful couples. Many times, the people actually see themselves in my photos and they sort of resonate with that look. What you show is what you get.

BH: In looking at your images, I get the sense that you are a European photographer or that you shoot a lot in Europe. Is that an accurate perception?
JV: Yeah, I do shoot a lot in Europe. I'd say I do a nice handful of weddings there, along with some portraits, family portraits, even engagement sessions and things like that. I'm very inspired by Italy and I

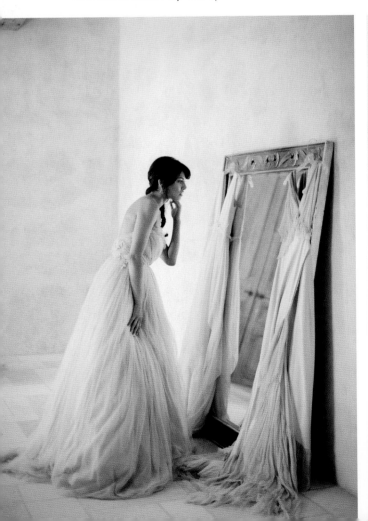

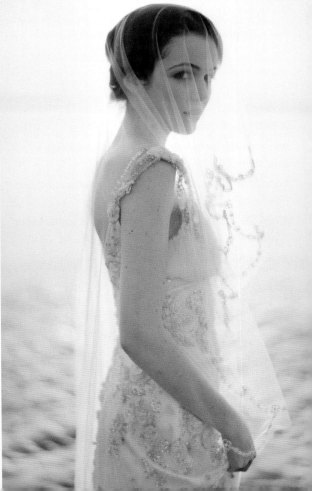

love the light there. It is very similar to what I would say California light is like.

BH: How do you pitch your style of weddings?

JV: I have been shooting weddings for twelve years. I started photographing weddings when I was twenty and my clients were older than I was. Now I am in my early thirties and I am shooting couples who are younger than I am—and the trend that I have seen today with a lot of these clients is that they are finding me through social media. I have a wedding this Sunday, in Sardinia, Italy, and the couple found me on Instagram. All of the images I post on Instagram are really images that I would post on my gallery website. I don't post a lot of personal images. I don't post what I'm eating today—I don't believe in that for my business. It's a very professional business and I want people to see how I see the world with an iPhone. On my Instagram, I started with an iPhone and I feel like that has attracted a lot of the younger brides, which, of course, I am very inspired by.

A lot of the younger brides love film and the reason they love film is because digital has been around for twelve or thirteen years. These brides who are accustomed to digital haven't seen film in a very long time. For them, film is different, which means that is what they want for their weddings. They also know that film is a higher quality and they love that. They see that it looks timeless. It's not oversharpened and things like that. So I'm very much attracting those types of clients and I think that's because I push myself as a film photographer. I am pitching myself with these younger brides and that really sells itself. I don't have to spend any money on advertising. I do have to be careful because I don't want to sell out. I don't want to be that photographer who just posts like crazy.

BH: What equipment do you use – lights, cameras, lenses, software, etc.?

JV: The camera that I mostly use is a Contax 645—and that's medium format. I also use a 35mm Canon IV, a film camera. My favorite lens with my Contax

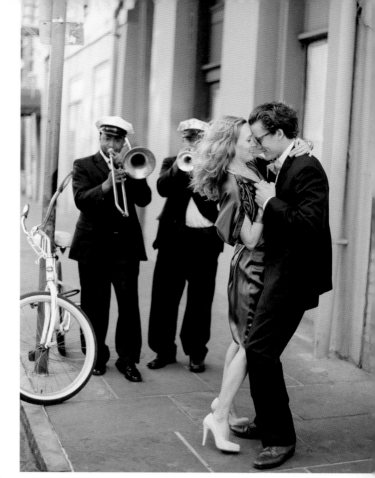

645 is an 80mm f/2.0. I also use a 35mm f/2.8 and a macro 100mm f/2.8. In Canon lenses, I have a 70–200mm f/2.8, a 50mm f/1.2, and a 35mm f/1.4.

For lighting, I most often use a video light. I prefer natural light. I also use on-camera flash when needed and I shoot with the flash in E-TTL mode.

The computer I use is, of course, a Mac. I think most people in this business use Apple computers. For software, I tend to just stick to Bridge and Photoshop. I don't use Lightroom. I don't use any other software at all.

BH: You work in pastels to a great degree – but I guess that is shifting your exposure emphasis toward the highlights and letting some of the harsher, darker tones go away. Is that an accurate description?

JV: That is very accurate, yes. I'm always metering for the shadow which, of course, makes everything else lighter. It makes the darker areas neutral and I

am also very careful with my compositions. I don't usually like to photograph in darker areas. I don't like black in my photos. I think a black doorway or a black tree trunk, for example, tend to go too dark and to me it looks like a hole—so your eye goes directly to that black area, which is a distraction.

I always seek out lighting and backdrops that have a very consistent look and tone to them and that is just because I think my eye is trained that way. I don't necessarily like the color black in design and even on my website; my website is completely white and soft. You know, I keep in mind that weddings are white in most cases, weddings are soft. They're beautiful. They're light in tone. They're feminine. When I see the world, I see it that way and clients tend to really gravitate towards that as well.

BH: Do you do your own postproduction or do you send it out? Or is it something you supervise?
JV: I send that out to Richard Photo Lab in Los Angeles, and they do all of my film processing, and

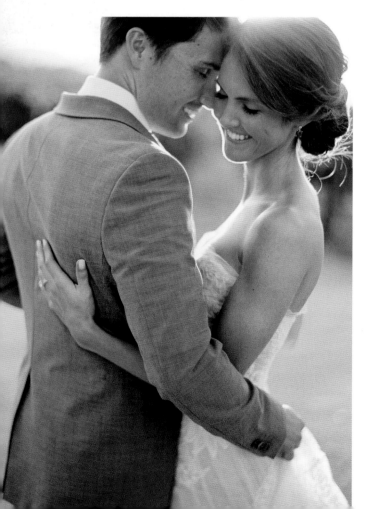

scanning, and all of my printing. I've been using them for about nine years now and so they do all of that postproduction for me. When I get the files back and they are printed, of course, we give the client a set. The files in the digital format are the images that I post on my blog or on my website gallery. These images do have a little bit of polishing. What that means is that I'm bringing the images into Photoshop, where I'm looking for anything that might be a distraction. It might be as simple as a piece of trash on the ground or it might be a rock in the background that is black and I might take that rock out if it is small enough. One rule that I have for myself is if I work on an image for more than sixty seconds, it's not good enough so I won't show it.

So that's "my little rule" because, you know, as a film photographer the whole idea here is you don't have to do anything in your computer. If you are, then why are you shooting film? You might as well shoot digital, you know?

As a film photographer, [you want] to be able to just get rid of the computer completely and free your time to do other things with your business—whether you're shooting more, or advertising for yourself, or traveling, or whatever. That is the freedom that we have as film photographers. But I will say you have to get it right in-camera—and I can say that even for digital photographers.

I meet so many photographers because I do these photography workshops, and I can tell you that out of all the years that I have done this, I have asked every single class, "Who here loves to edit? Who here loves to Photoshop their images and spend time on their photos?" Honestly, in the last eight years I've only had two people say that they absolutely love to be in front of the computer for hours and hours, just working on images.

BH: You do so much photography outside the country. Do you have the film processed on-site, or do you wait until you get back to have it processed by your lab?
JV: I wait until I get back and then I have it processed by my lab. Just because we have a formula, it's really

hard to work with other labs around the country or around the world. It is really difficult now to find photo labs anywhere in the world, actually.

I'm kind of a control freak/perfectionist. So I bring it back home and I send it to the actual scanner himself who does all of the work for me because I don't just send the rolls of film to the lab for anybody to process them and then scan them. There's actually one person, his name is Mike, and he does everything for me because I've been working with him for eight years and he knows exactly what I like.

BH: How do you prevent X-ray damage to your film?
JV: Yeah, so that's a good question. Anything that's below ISO 800 we run through the X-ray machine. It's fine. But anything that is 800, 1600, 3200—all of that is hand-inspected. So, we give ourselves a little bit of extra time when we are going through security.

BH: I'm surprised you would let any of it go through X-ray. Are the different intensity X-ray machines a bother?
JV: That is something we've tested and we've always worried about but, typically, with the 400 speed and the 100 speed films, the negatives are not sensitive enough to X-radiation, so they are totally fine. But it is a risk that we take in every situation. Knock on wood—I've been doing that for years and years and I haven't had any issues with the 400.

BH: So how many assistants do you have?
JV: I actually have three. One is my studio manager, so she basically manages all of my appointments and my other employees. Then I have my sister, whom I would consider to be my personal assistant, so she does all of my bills and all of these things that I can't get to—including personal stuff, which there is not a lot of. She'll work on reprints for the client and building small albums, editing images, pulling images, of course, archiving images, and organization of all the images. I also have a girl who does all of my design. Not only does she do all my albums—I do about sixty a year and we also do about eighty engagement albums a year—but she does all my

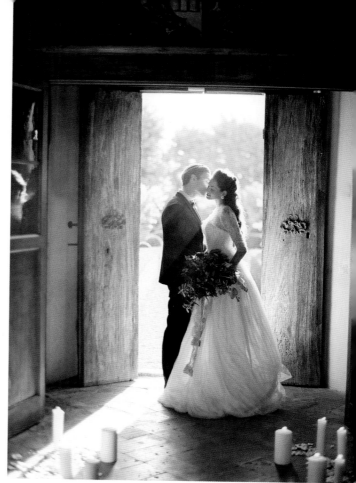

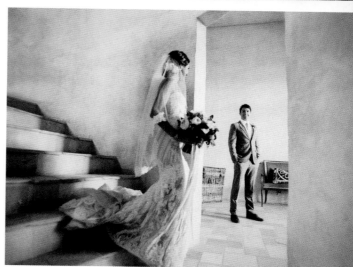

other designs and anything for marketing, a blog, the website and web design, logos, and more. All three are full time.

BH: You're a busy guy.

JV: Yeah, I'm shooting about fifty weddings a year. So, it's pretty busy—and then, depending on the year, I do sixty to eighty engagement sessions. Last year, I did about seventy.

BH: You're considered a big success in today's wedding market. You partially answered this earlier, but what are some of the elements of your success? What separates you from your competition?

JV: I've learned from just doing this for such a long time—and from seeing a lot of new photographers come into the business. I've seen some successes and I've seen some failures. I study things like that because it makes me nervous. I don't think I can see myself doing anything else but taking photographs— and I'm not really sure they could answer that same question.

For me, I'm very passionate about one thing and that's photography. I felt like I needed a goal to master this thing that I do. I didn't want to be a jack

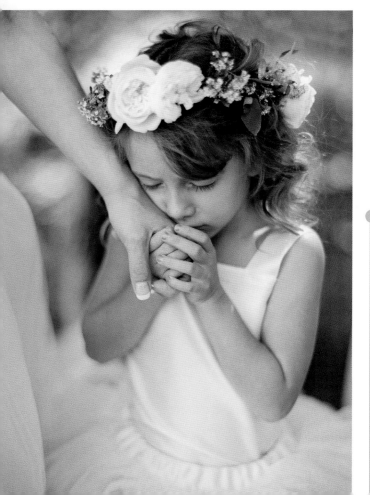

of all trades. I wanted to do this and I wanted to do this completely 100 percent correctly and beautifully in my own way.

Being in the right time and the right place, I think, is really important. I came into this industry when I was—gosh—twenty years old. I know you can remember photographers who were at the top of the game. Things change; trends change. I mean, we don't hear about them at all in this industry anymore. For example, photojournalism is still a thing for some people, but it's not really the thing for the wedding industry. In my opinion, it's more about lifestyle photography, more about the details, more about telling a beautiful story—but directing. So that was something that I really truly believed twelve years ago and that was a decision I made—to continue to shoot that way because that was the way that I felt was the right way for me. The great thing about that is that now it is what people want to shoot. It's more like images that were torn out of a magazine.

One of the biggest things that I've learned is follow-through. I'm a huge believer in keeping your word, whether it's with a bride or with a vendor. A lot of my work comes from other vendors—we're talking about the wedding planner, floral designer, cake maker, and so on. So part of what you're doing on the wedding day is photographing their creations. The follow-through part comes in getting them prints of their creations.

Take the cake baker. He wants to show a beautiful photo of his product to prospective clients. So if you're not going to follow through and give images to

"I didn't want to be a jack of all trades. I wanted to do this and I wanted to do this completely 100 percent correctly and beautifully in my own way."

these vendors, you're shooting yourself in the foot. They're going to use these images to promote you for free. The more you're seen and the more exposure you get, the more jobs you'll get. I feel like a lot of photographers tend to forget about that because, you know, a lot of us are artists. I understand that we really just want to focus on making pretty photos, but you also have to have a balance of thinking about your business and thinking about getting the next client and getting yourself to that next level. I could never do the wedding or make the wedding look amazing if it wasn't for these other vendors that made it that way. You know, hair and makeup people are another example. All of these people—you have to respect their time and their efforts because that is how the world sees their new work.

So many photographers are such amazing artists, and they'll continue to make incredible photos. Unfortunately, they don't all have the skill or the education or the craving or the drive or whatever to get their images out there. That is something that I think I have been really big about—and I've noticed that some of the most successful photographers do the same thing.

BH: Your cakes are fantastic. They got me very hungry! Some of those cakes—I'd never seen anything like them before. The way you photographed them seems like the way you work with models.

JV: And that is exactly right. It's like I'm putting the cake in the same lighting as I would a person. I'm treating the bouquet or that place setting or that floral piece or bottle of champagne in the same way.

I'm very big on consistency. I want to make sure that if we're building an album for somebody, the album is going to be consistent with the lighting all the way through.

As you know, more than anybody, wedding photographers are thrown into four or five or six different lighting situations on the wedding day. We have to balance all of those lighting situations to make it a complete and consistent wedding. For film photographers, it's even more of a challenge

because we have to use five or six different types of film to make it that way. It's definitely a little bit of a challenge, but I do keep that in mind when I photograph *everything* as if it was a person.

BH: One of the most beautiful things you can do with film is shoot wide open and give your background a muted, soft

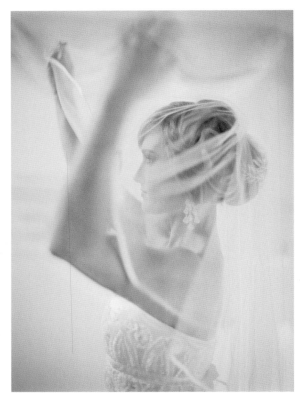

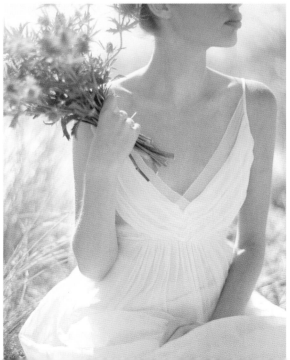

effect. That's a lot of what I noticed in your images. With digital, even with fast lenses, you don't get that softness back there.

JV: I'm shooting everything wide open. Most of the images that I sent you were shot with my medium format Contax with the 80mm lens I always have on it at f/2.0. So I'm always shooting with the shallowest depth of field to be able to achieve that look that you just described.

BH: What are your goals for the future? Where do you see yourself in ten years?

JV: That's a good question because I talked to you about longevity. I don't have a family now, but I would love to start a family and I always want to continue to have photography in my life—but you know wedding photography can be tiring. It's a lot of work and, after doing this for so long, even at thirty I feel my body getting a little tired.

And so I think the biggest thing is I just don't want to burn out. As a wedding photographer shooting forty weddings a year, you can burn out. My goals in the future are to incorporate more editorial work and take on fewer weddings. Raise my rates with my weddings and maybe do ten weddings a year and travel and do more editorial work for clients like *Condé Nast Traveler* and more things like that. I'm very inspired by their magazine, and also there's sort of a trend right now that a lot of photographers are hopping on, which is to photograph for these beautiful resorts all around the world. You go and photograph the resort and you have a wedding planner/designer come and design something like a table setting or a living space in a room or a lobby and then you photograph it with real models but you don't make it too "hotel" or too cheesy. You make it lifestyle and then they use the images for their marketing.

I just came back from Bora Bora, where the Four Seasons Bora Bora sent us out to do exactly that. We had a model and we were there for five days. We swam with sharks, and they gave us massages—because they wanted us, as professionals

in this industry, to experience this so that we could recommend it to our clients and get it out in the wedding industry. It's becoming a trend. I'm not the only photographer who does this. Eventually, I think it would be really fun to do that a couple of times a year—but this time I would like to get paid.

I already have a book out, but I am working on a fine-art book where it's just images of my travels and images that inspire people in the wedding industry—so that's kind of in the future, as well. It's already designed. I'm working on it currently and I'm hoping to get it self-published. The book itself will be about 11x12-inches. So, it will be a little bigger and the images will be larger, but it's not a lot of text. It's primarily photographs and it's going to be a hard-cover canvas book with gold foil embossing, with a canvas cloth slipcover. It will be about $120. So, I'm working on that slowly, but surely.

BH: What were you doing before you became a photographer?

JV: I came right out of a high school and went directly to Brooks Institute of Photography. So photography has always been the thing for me. I had jobs here and there. I worked at a Rite-Aid Pharmacy. I was in the photo department and I started really getting to know how to play with different colors and all these things with dialing in color and lift-out and that kind of stuff. So that was kind of cool, but that's nothing, I mean, *major.*

BH: Tell me about your most-used photographic techniques and why they're your favorites.

JV: One of the major techniques I use is to meter to the shadow areas of everything I photograph. The second thing is that I overexpose my film by a stop and then I use lenses that have a very shallow depth field and I shoot wide open. I also use as much natural light as possible, but when I am using flash, I do have it on-camera and then do E-TTL at minus one-third [stop].

So that's the formula. I'm a minimalist, so I try to use as little equipment as possible. I like to just

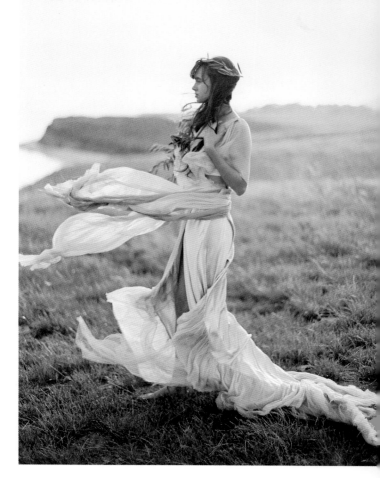

keep it as simple as possible. So those are the typical techniques I use every time I shoot.

BH: Do you have a game plan for a wedding you're photographing?

JV: I would say yes and no. I mean, I realize that weddings are, in most cases, pretty much the same. It has a ceremony, a reception and dancing, and mostly eating and drinking, and celebrations, and things like this—first dances and so on.

I get burned out by the idea of weddings being all the same. So there are certain things that I do and make sure that I get—the family portraits and the typical things. But I also like to just let the day unfold. Every wedding is a living, breathing thing and I do like to let this thing just live and breathe and then capture it. But, then I do insert myself as certain things happen. There's a fine line between the inserting of yourself and not. I don't want to ever

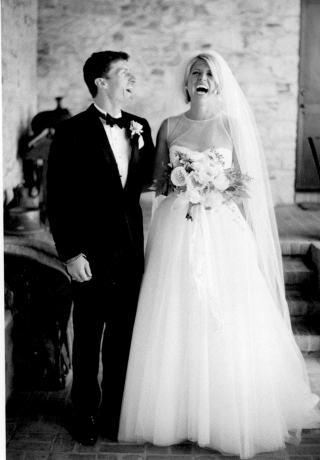

interrupt any moments that I think would never be re-created again, so then I become a journalistic photographer for five minutes.

And then, in the next five minutes, something happens but it doesn't look as good as I want it to be—but it's not the ceremony, so I can direct a little more. And then I become the fine-art photographer who is more the art director.

So there is definitely a mix of both—where there is a game plan, but then there may not be because I do like the element of surprise and the element of knowing that something may or may not happen. Or there's drama or there's all these crazy things that happen. I don't feel I could ever have a real plan because things just happen. It's a living thing.

BH: Do you use a second shooter?

JV: I always work with an assistant, and I would say that with maybe 25 to 30 percent of my weddings

we are incorporating a second shooter. When the wedding is large in the number of guests—200 to 500 people—we usually have a second shooter because I can't be at all places at once. She'll cover more of the people, more of the extended family and guests, and with my assistant I'll cover more of the immediate family and the bride and groom.

BH: What type of wedding photographer do you consider yourself to be?

JV: I always say I am a fine-art wedding photographer. And actually that's the name of my book, *Fine Art Wedding Photography,* which is doing very well.

BH: Was there anyone you were most influenced by in your early years?

JV: I never had a family I would say was very artistic, so I was influenced by friends of mine whose parents were painters. Some were even photographers. So

I was very intrigued. I really wanted to know more about what they did. One of my better friends, his mom was a sculptor. I was inspired by that. It's just that my parents didn't do any of that. And so I was like, 'What is this and how is this? And how can it be this way? How do they make money?' And so, even in my younger years, you know, my friends' parents had big houses and all these fancy things. Not that I wanted them necessarily but that we didn't have that and we were the complete opposite.

Also, I was influenced by where I grew up. I grew up on a ranch with horses and animals, running rivers, and light—tons of light, tons of soft, beautiful colors—so I was very inspired, I think, by that.

I was also influenced by Joyce Wilson at Brooks. She was probably one of the most influential people for me going through Brooks. On an internship, I was influenced by a photographer in San Francisco who did editorial fashion photography—her name is Marcy Malloy.

BH: I get the sense that you are a lot like the naturalists, who were not inspired by people necessarily, but more by the elements of nature.

JV: Yeah, I think you're pretty accurate. That's definitely what I was really inspired by. And then when I found photography, that was a way of capturing all that. And then when I realized I needed to make money, that meant incorporating humans and them paying me for portraits where I would place them in these gorgeous locations!

Location is my number one thing. And then people started paying me and I was like, "Wow— that's the main thing!" Then they started paying me more. I thought, "Oh my gosh!" and I kept with it.

You know, most of my clients are exactly like I am. They grew up on ranches, they love riding horses, they love drinking wine. They have a vineyard, they own ranches and chateaus, and they are inspired by the beauty of nature. So it actually is perfect to have the clients that I have—but it took a long time to get those clients. It was about just showing the work and getting it out there.

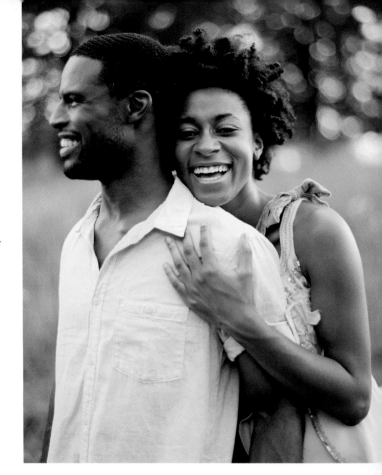

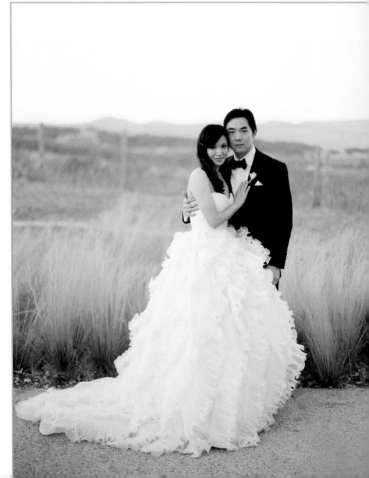

Paul Ernest
Managing Expectations

Dallas wedding photographer Paul Ernest is a documentary lifestyle photographer, specializing in both artistic traditional and editorial/photojournalistic-style wedding photography. Paul serves Dallas/Fort Worth and the surrounding areas but also photographs national and international weddings. He came to photography after nearly twenty years in advertising, bringing along all the skills he learned as a creative director on shoots with other photographers. In his first print competition, the 2011 WPPI Awards of Excellence, he swept the entire Premiere category – taking home the first, second, and third-place awards, as well as the coveted Grand Award and over twenty Accolades of Excellence. In June of 2011, he received the Diamond Photographer of the Year Award at the Imaging USA 2012 award show, and all four of the images he submitted to the PPA International Print Competition were accepted into their Loan Collection. *(www.paulernest.com)*

There are a wide array of inspirations in Paul's career. He describes his youth. "My inspirations, and those that made an impression on me, began as a boy. My great grandmother was a writer who taught me to think through stories. My grandfather was an artist in several disciplines, including painting and sculpture. Art was all around me growing up. The reason these two people were such important influences is because I was raised by my grandparents after the death of my parents when I was an infant.

"I absorbed the influence of a generation that made me identify with American Realism (Wyeth, Rockwell, Johnson, and Millet), photojournalism (Lange, Leibovitz, Bourke-White, and Rothstein), writers (Emerson and Whitman), and even the likes

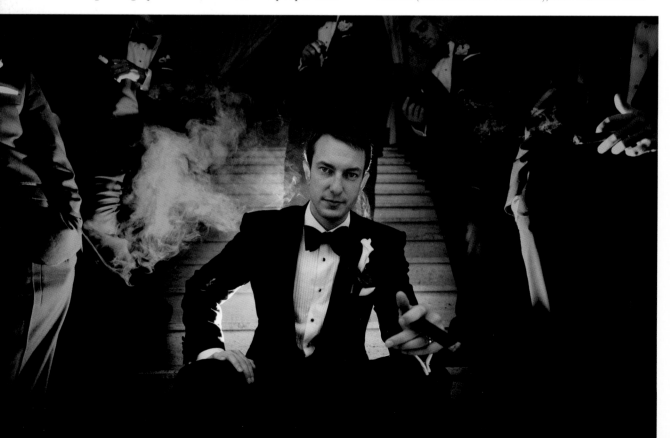

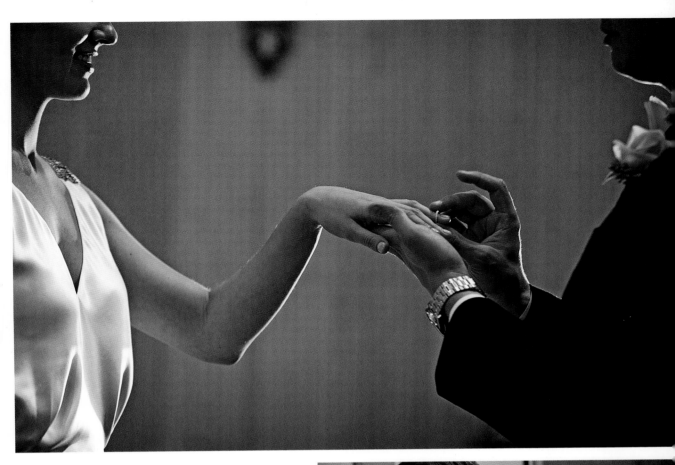

of cartoonist Bill Mauldin. In college, I decided to pursue design and advertising with a double minor in cinema and photography."

Professional Skills

"I knew that if I wanted to become an art director, I needed a working knowledge of photography (print ads) and cinema (commercials). Having had a camera in my hands as a teenager made photography come easy. But the exposure in cinema to artists such as Kaminski, Deakins, and Cortez made me really stop and think about the fusion of cinematography, writing, and painting. It revealed to me a way of thinking that I didn't fully comprehend until I left the advertising world. By that time, not only did I have experience in the commercial world, but I was able to apply all of that knowledge in a way that allows me to bring emotion, storytelling, light, composition, history, and culture into my photography.

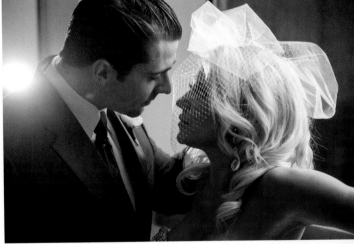

"The key that allows me to use these tools is the ability to adapt. No two agencies or clients are the same, just as no two brides are the same—hence, their stories are not the same. I have to use the tools of my own life experience in a way that resonates emotionally with my client."

Personal Skills

Paul says there are also some necessary personal skills. "In the field of design, I learned to develop a thick skin and be adaptable. These are *musts*! You can't take it personally and you have to adapt to deliver and to stay on your game. If you let either of these defenses down, you open yourself to limited creativity and an unclear thought process. I learned to slow down, check my process, and solve the problem. I think that the influences in my life impressed this upon me to allow creativity to prevail in any situation."

His Business

Paul's skills led him to a career in advertising, where he stayed for seventeen years. After all that time directing photographers, Paul decided to take the skills and insight he learned as a creative director and move into photography himself. While Paul has many other interests, such as fine-art photography and book publishing, he remains a premier wedding photographer.

> "In the field of design, I learned to develop a thick skin and be adaptable. These are *musts*! You can't take it personally and you have to adapt to deliver and to stay on your game."

Tools

"I am a third-generation Nikon user," says Paul. "Lighting to me is about the quality of light and not the brand. I use professional lighting (Einstein's) as well as Nikon Speedlights when I need strobe

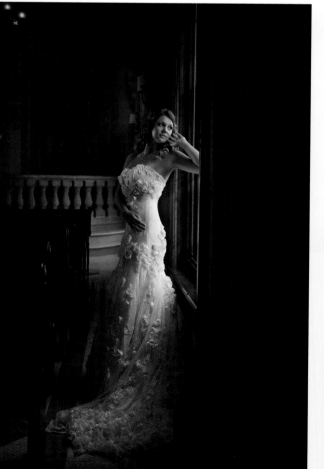

Studio and Organization

Paul's wedding studio, by design a small one, is structured uniquely since he has two distinct objectives: to run a fine-art portrait studio and to provide illustrative services. There is no studio shooting space since the client work is all done on location. "We have a quaint meeting space, an editing office, and a production room for any framing and mounting done in the studio," says Paul.

According to Paul, "The challenge we face daily is managing deadlines, expectations, and quality. It is a balance using communication and synchronized calendars. Most times, we schedule bridals and engagements early in the week."

lighting—but I use homemade reflectors, video lights, and even flashlights to get the effects I want. I am always trying to develop unique, inexpensive lighting tools.

"When it comes to software, I keep it just as simple. First, Apple computer products are my go-to. My software includes Photoshop, Bridge, Lightroom, and even Illustrator at times. I try to stay away from too many actions. As a craftsman, I want to create my own recipes in Photoshop. The one software that I will suggest in post is OnOne. The ability to build or layer using their tools has come in handy for high-volume production projects. The only other tool I utilize in the design phase is Fundy AlbumBuilder."

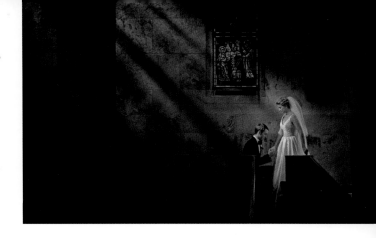

Building on the Light

"In general, my intent with light is to create a scene, portrait, or image that does not look intentionally lit. Some of this comes from the influence of cinema and painting."

When Paul is shooting, the first thing he looks at is the available lighting. "I ask myself, 'How can I build on that? What can I do to enhance the natural lighting situation?'" he says. "Sometimes, a primary light source doesn't present itself. At that point, I try to start from scratch by overpowering the ambient light or eliminating it. Directional light is primarily my approach. I use whatever I can to achieve the light I need."

The Artist Gallery

Generally, Paul will cull the images. He will then edit the images or send them out to a third party,

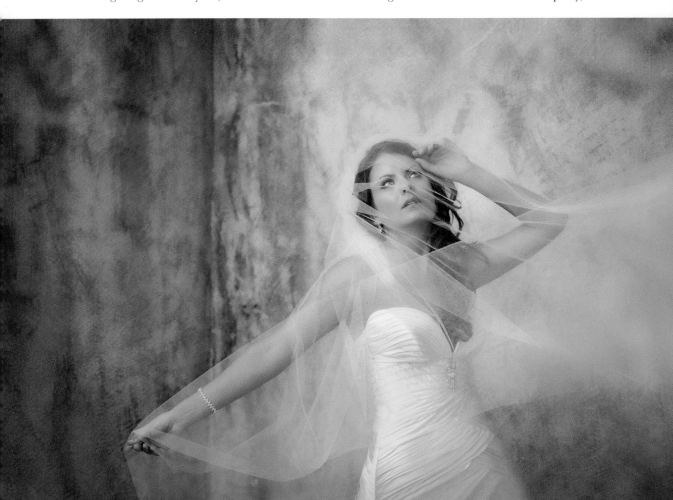

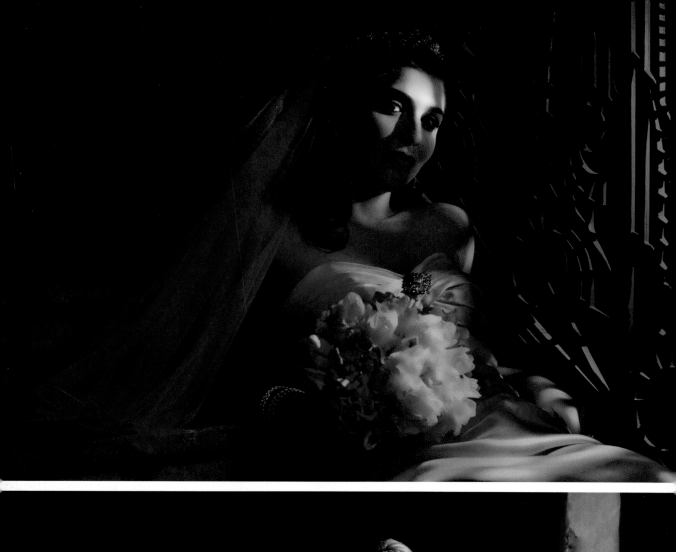
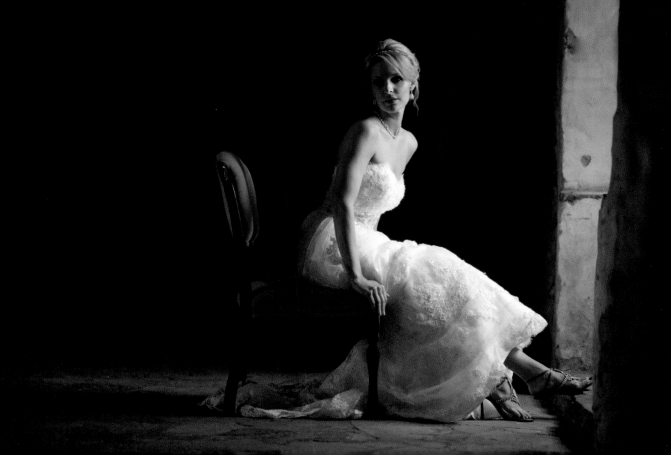

depending on how busy they are at the studio. Usually, he will pull a select group of images that he wants to bring into what he calls the "artist gallery" of images, on which he does further illustrative enhancement. Paul says, "The 'artist gallery' is the group of images that brings my signature look to the series. It's the group that would primarily be used for the couple's wall art and album."

Style

"Let's face it, the camera is a tool. It has, over time, become a smarter tool—a tool that can compensate for lack of knowledge and experience. So what then? Let's put it another way. Does the highest-quality saw create a fine piece of furniture? No. It has to do with the carpenter. That said, it is utterly and completely up to the photographer to create a style, an approach, or even a genre. For me, personally, my style is *me*. It is a combination of experience, influence, and passion. It's art, literature, and storytelling, commercial influence, and cinema. If you can see light—if you can control and modify

light—if you can visualize the composition and reveal the story, then the rest becomes your style."

Paul has definite opinions about being classified as a certain type of photographer. "I am not sure I would put myself into a genre, although most would call my style fine art. When I am shooting a moment, I see it as a photojournalist. When I see rings, I see myself as a product photographer. When I shoot families, I see myself as a traditional photographer. When I see a bridal opportunity, I see fashion. In all, I see fine art."

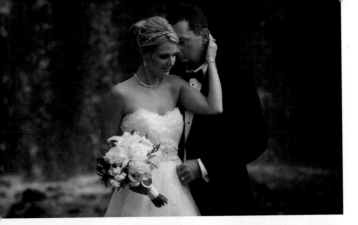

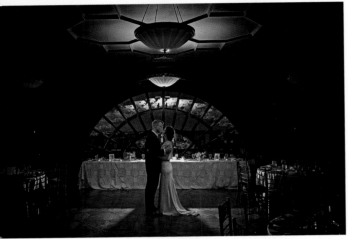

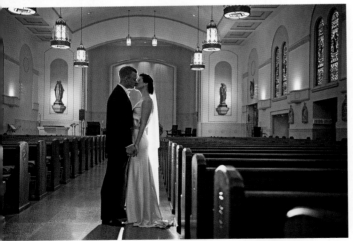

Asked to elaborate on a few specific elements that define his style, Paul replied, "Tonal values are a big deal to me—how they can be used to create an image and not just a 'photo.' Storytelling is another focus. If this image had to stand alone to tell the story of the day, what would it say? Framing and cinematic composition are important in making the image 'complete.' When you watch a movie, each scene is set by an establishing shot. How can I take that mental focus and turn it into that 'story?' Sometimes I think of my clients as actors playing out a real-life story. Then, I thread the entire wedding album together to create a visual novel."

The Game Plan

"The plan is key—no matter what the shoot. I remember my days as an art director when stylists, storyboards, shoots, schedules, timing, location, and budget were all part of the process. They all apply just the same to weddings. Managing expectations is even more important when you are dealing with emotions, heirlooms, and budgets. It can sound like putting creativity in a box, but it is actually quite the opposite. If these things aren't covered and you have a client expecting art, and they get mere 'photos,' then some part has been compromised."

Client Satisfaction

"My philosophy of wedding photography is fairly traditional. A client comes to you because of a referral, or they see your style. Everyone is different, but all have an opinion. To me, the challenge is meeting their preferences while adhering to your style. I grew up in a home where I was taught that the customer is always right. While I might not appreciate a specific photographic request, I will shoot it to the best of my ability—that is what they want and what they are paying for. Too many times I hear of photographers who would die on the sword of artistic freedom rather than doing what the client wants. I have to remember this is *their* heirloom and they are paying with *their* money. At the end of the day, I want happiness from my clients."

The Future

Some of Paul's aims for the future include refining his style, refining his client list, and pursuing his fine art—these are his immediate goals. He says, "At the end of the day, I think it comes down to contentment—in artistic fulfillment, in the business, and in the satisfaction of happy clients. These are some great things. When it comes specifically to weddings, what makes me most happy is knowing that what I capture and create will outlive me. These will be the things that families will cherish for generations."

Who I Am—In Five Words

I pulled this off Paul's website because it embodies his philosophy and his love and passion for his craft. It is also sage advice from a man who has already enjoyed several successful careers.

Design. After spending many years in design and advertising, I decided to step from beside the lens to behind the lens. The years in design and working with dozens of photographers have brought me the seasoned ability to compose images.

Photography. I have always loved photography as a form of art and its ability to capture a moment forever—images move, inspire, and remember. Photography has brought me the respect and reverence of the art.

People. I love people and their lives and stories. Before my career in design, I considered enrolling in seminary to serve people and their lives. I was taught throughout my life to serve others, to be involved in their lives, and to encourage people in this life. People have brought me encouragement and hope.

Art. I come from a family of artisans who have influenced and supported the importance of the beauty and creativity of art and design. Emotion and reflection are the products that art brings to all of us. Seeing the beauty created by people has brought me joy.

Commitment. My father's primary lesson in life was commitment—commitment to what you do, how you serve, and the people you are with, to follow through and be an anchor to yourself and who you are with. Commitment has brought me wealth in relationships.

Morgan Lynn Razi
Realizing a Dream

Morgan Lynn Razi founded her photography business on a part-time basis at the age of eighteen. After earning bachelors degrees in business and fine arts/photography, she worked in public relations for three years before deciding to devote herself full time to professional photography. In 2011, she was joined in the business by her husband, Amir, who shares both shooting and operational duties. Based in Houston, the couple documents weddings all over the globe. Morgan was recently recognized by *American Photo* magazine as one of the top ten wedding photographers in the world. *(www.morganlynnphotography.com)*

*M*organ Lynn Razi met both of her great loves—photography and her husband-to-be—when she was just fifteen years old. By the time she was a fine-art photography and business student at the University of Colorado in Boulder, she was already shooting weddings—even though her sideline didn't impress her instructors or peers. "I didn't feel like it was a cool, hip thing to do," she says. But she combined her artistic training with a meticulous technical approach and came into her own just as wedding photography was becoming more respected. "Now it's a really desirable job to get into," she says.

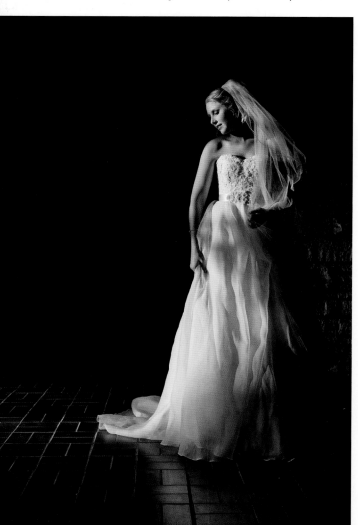

Inspired by Love

Even more than her photographic skills, it's Morgan's affinity for great love stories that allows her to bring out the beauty in each event. "I get excited and inspired by people's joy and emotion—and by people who are in love," she says. "I can really relate to that because I've been so lucky in love."

The couple is now based in Houston, where her husband, Amir, has recently started shooting with her full-time. Morgan applies her ample technical skills in the event halls where receptions with elaborate and varied lighting are often held, seeing the possibilities in challenges that many photographers would find daunting. Her view reflects the sanguine attitude she has toward every wedding she captures. "I probably have rose-colored glasses on," she says, "but I want to

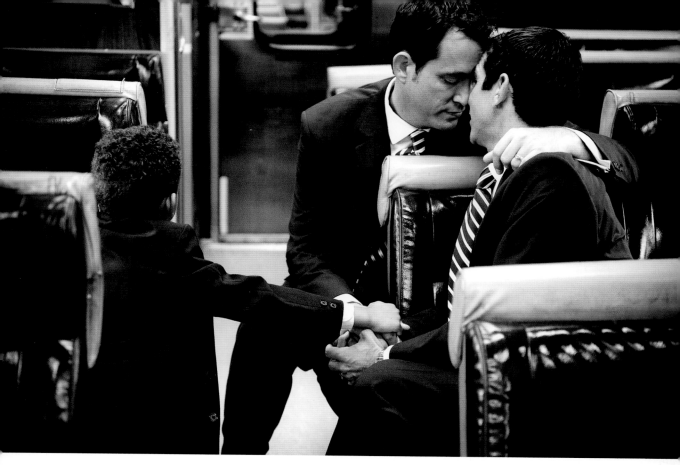

believe that these two people are insanely in love with each other."

Becoming a Professional Photographer

Morgan spent her whole life preparing to become a wedding photographer. "I've been taking photos since I was fifteen and operating my photography business since the age of eighteen. I was an avid art student and was either painting, drawing, or taking pictures throughout primary school. Being involved in art from a young age really helped me develop my eye for color and composition, which has definitely carried over to my photography.

"That said, I didn't grow up planning to become a professional photographer—not because I wouldn't have wanted to, but because it didn't seem like a viable career option. Wedding photography wasn't 'hip' like it is today. The cost of entry was high and the learning curve steep. Film was not as forgiving for beginners—especially at weddings.

"I've always been a hard worker with an entrepreneurial spirit and ultimately decided to pursue a business degree in marketing and entrepreneurship. I was still accepting paid photography jobs during my first two years of college and realized that I needed more of a creative outlet in my education. Though it was expensive and time-consuming, I opted to pursue a second degree program in fine arts/photography. It would be my plan B career should I ever find myself struggling to make it in the business world.

"After graduating with two bachelor degrees, I immediately turned toward a marketing/public

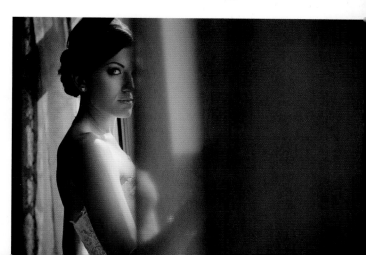

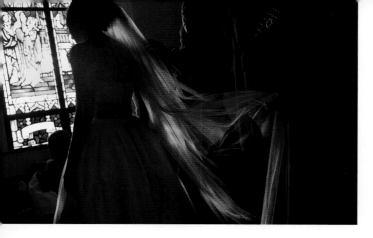

relations career. The prospect of earning a steady salary for the first time in my life was too alluring! All the while, I spent my free time shooting—families, newborns, seniors, and a handful of weddings fell into my lap each year through referrals.

"Eventually, I began to realize that, as uncertain as a career in wedding photography was, it was my destiny. There was nothing I enjoyed more. After three years of feeling professionally divided, I left my job at a public relations firm in Houston to begin my career as a full-time wedding photographer. I shot forty weddings that year without investing in advertising.

"It was exhilarating to be able to fully succumb to my greatest passion and give it every ounce of effort I had. In a short time, wedding photography turned out to be a very profitable career move. I'm so thankful for each and every experience that led me to realizing my dream, and I absolutely believe it helped prepare me for what I am doing now. Wedding photography is a business, and I think too many artists learn that the hard way. It's so much more than shooting. My background in marketing and public relations gave me a real-world perspective on business, branding, communication, and customer service. I utilize those skills on a daily basis."

Teamwork

Morgan's husband Amir received his Bachelor of Science degree in Mechanical Engineering from The Colorado School of Mines.

After twelve years together, Morgan convinced Amir to share her passion—and in 2011, Morgan

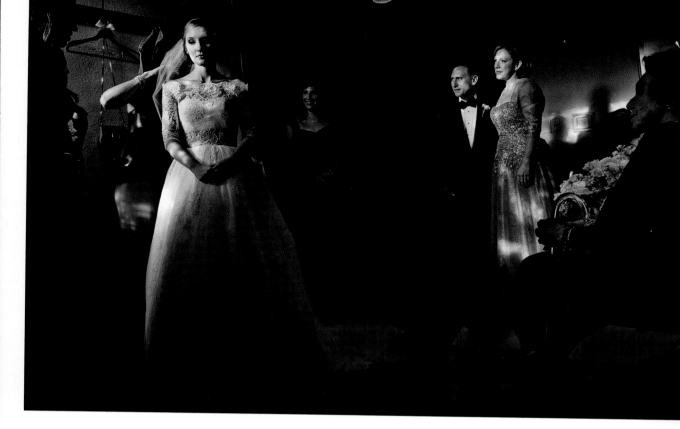

Lynn Photography became a husband-and-wife team. Amir is the studio's second primary shooter and the unofficial studio manager for the staff. He serves as a liaison between contractors, interns, and third-party vendors. He handles all correspondence and image-share requests from coordinators, wedding blogs, florists, musicians, etc.

Amir's background in engineering also makes him the studio's go-to for all IT-related projects. He manages and oversees all server and website/blog updates. Additionally, Amir conducts the primary round of culling images before turning them over to Morgan for the final selection. After the wedding images have been processed and delivered, Amir coordinates with couples on the design and completion of all album orders, as well as all print orders. In short, Amir is indispensable to the running and everyday management of studio operations.

Organization

Organization has many facets at Morgan Lynn Photography. "In some ways, I tend to be somewhat old school," says Morgan. "I still use a traditional planner to keep track of appointments and shoots and have never been able to completely convert to a digital scheduler. I find it easier for making quick notes, even in this digital age. Our studio is comprised of only a few people at any given time, and I haven't had the need to modify my scheduling habits. I place trust in my team to keep track of key dates in their preferred way. As we move toward expanding our business with the addition of a second studio, we'll adopt a full-fledged studio-management system." Morgan suspects, however, she'll still keep her trusty planner within reach.

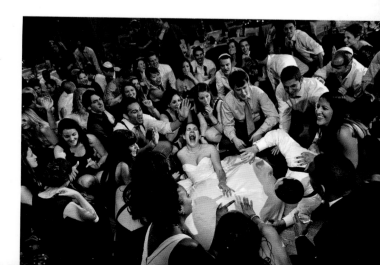

On the other hand, the studio's system of data organization is extremely up-to-date and streamlined for security and ease of access. Amir uses a two-server system and is extremely methodical in how data is archived and accessed.

There are several levels of quality control in place, which, in a small studio, means that they are often contributing ideas to each other's projects on a daily basis. Each person has unique perspectives and skills to bring to the table, and their collaboration and resistance to traditional "roles" gives the studio synergy and keeps day-to-day work interesting. Division of work within the studio is based on strengths, and each of the people on staff wear many different hats.

Morgan's background in business, coupled with her industry experience, is part of the reason she handles much of the client correspondence. "We strongly believe in creating a personal experience for our clients, and being able to pick up the phone or send me a direct e-mail is part of achieving that," she says. Morgan advises clients on everything from wedding-day timelines, to attire for portrait sessions, to venue selection when appropriate.

Scheduling and Consultations

Since Morgan Lynn Photography doesn't have a photography studio in the traditional sense, their in-house work with brides and grooms consists of meetings, communication via e-mail or phone, shooting on location, and postprocessing. After the initial consultation and booking, Morgan coordinates with the brides and grooms as needed to answer questions, schedule and conduct portrait sessions, complete print orders, etc. Their philosophy is not to limit how much time is devoted to each client— though some require significantly more attention than others.

A Home-Based Studio

Most of the weddings are on location within or just outside of Houston, Texas, where the team is based. On average, about 35 percent of their weddings each year are outside of the city, state, or country.

All consultations with local clients are done in Morgan and Amir's home studio, which is a three-story building with ample space to display their award-winning work. In addition to the first level (bottom-left image), which serves as a presentation/meeting space, the third floor of their home is entirely devoted to in-house printing and their workstations (bottom right image). This is where the staff, including interns and associates, does all of the postproduction, album design, printing, mat cutting, etc.

Morgan doesn't believe that a traditional brick-and-mortar studio is necessary for all wedding photography businesses (depending on the market dynamics of the city where the business is based). One of the most important factors the couple considered when making the decision to share their living space with their business was the impression they would be conveying to their prospective clients. The look and feel of the space both matter when brides and grooms are meeting with wedding vendors. According to Morgan, "Professionalism is one of our core values and one of the reasons we have such a successful, high-end business. Because of this, we have had to make lifestyle adjustments to accommodate our business objectives. For us, this means having a home studio that is uncluttered and decorated in a way that complements our work and helps support our studio's brand."

Morgan Lynn Photography recently relocated its home studio, partly because their area had experienced a surge of growth, making client parking difficult. "Our new location, though only a few blocks from our previous home, has ample parking and meets our professional and personal needs."

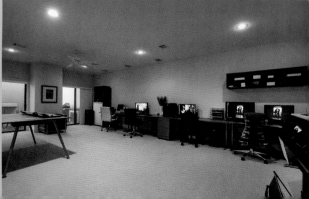

Skipping the Sales Pitch

Morgan says, "We never sit down for a consultation with a bride and groom with the intention of 'selling' our work. I have the mind-set that we are educating them on what we do, why we love it, and what that ultimately looks like." The majority of Morgan Lynn Photography's new clients come through referrals, so they generally have a good understanding of the studio's style. "It's important that we fully express our objectives on the wedding day, though, because we thrive on clients who put their trust in us. Trust leads to vulnerability, and we need our clients to be vulnerable in front of our cameras and have faith that the end result will be beautiful." She feels that it's essential they are a good fit philosophically with the couple; otherwise, Morgan will suggest a photographer more in keeping with their desires.

Inspiration in Emotion

Morgan's analysis of her creative inspiration is both simple and, like Morgan herself, not so simple. "Creatively, my inspiration is the play between

"We strongly believe in creating a personal experience for our clients, and being able to pick up the phone or send me a direct e-mail is part of achieving that."

shadows and light. I admit that I'm often stumped on a cloudy day until I can find a way to make the light more interesting. Sunlight and other ambient lighting sources are irresistible for me, especially on a wedding day. Even the most mundane room becomes sublime in the right light."

As cliché as it may sound, Morgan says her primary inspiration for shooting weddings comes from relationships and human emotion. "I've always been a sensitive person with an empathetic heart. When I am shooting a wedding, there is nothing that fuels my passion for documentary photography like true emotion. Even in my portrait work, I strive to capture the true connection between two people, not the artificial/commercial 'connection' that is so prevalent in wedding photography.

"I have to work for it, for sure. Most of the couples we photograph are not comfortable in front of the camera. They are not models, they are real people who have been conditioned to smile and 'say cheese' when a camera is pointed at them."

Early Influences

"When I was in college, I was fortunate to live and work with a family that was heavily into fine art. Over the course of three years working with this family, I became great friends with Natalie Rekstad-Lynn, who became a mentor. Natalie was such a role model for me, not only as an entrepreneurial woman, but also in the art world. She founded Salon d'Arts, which became an incredible success and later partnered with the Denver Arts Museum as Salon du Musée. Natalie entrusted the public relations activities to me and, through this experience, I gained exposure to some of the contemporary greats in fine art. Exposure to this world early in my career as an artist gave me perspective on how my own work could fit into the bigger picture. Several years ago, I was given the incredible opportunity of exhibiting several of my fine-art photographs in Salon du Musée at the Denver Arts Museum. When time allows, I hope to continue to develop my presence in the arts community as a fine-art photographer."

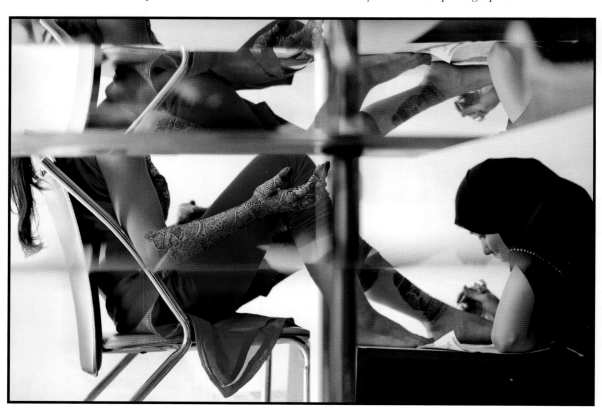

"Around the same time as I was fostering a relationship with the greater fine arts outside of school, I was working hard to find my place among my photography peers at the University of Colorado at Boulder. One particular professor of mine, Ken Iwamasa, played an interesting role in my development as a wedding photographer. No matter how hard I tried, I could never successfully 'shake up' my visual preferences enough to suit him. I admire him for pushing me past the literal and the 'beautiful'—but, ironically, that ended up being what made me the most successful in my photography career. I remember one instance when he said my work was 'too pretty.' It seemed like such a stigma then, but I find it comical now that I have come to understand the type of artist I am.

"As I began to really dive deep into wedding photography, I began to focus my attention on other photographers in the industry for inspiration. I discovered Matt Adcock, an Atlanta-based photographer, and fell in love with his dramatic compositions and creative use of light. His Flash Flavor blog (www.flashflavor.com) was one of my favorite go-to sites as I was learning about off-camera

Equipment

Here is a rundown of the equipment that Morgan and Amir use on wedding days and for image processing.

Cameras. Morgan's first digital DSLR was a Nikon D200, and she says she's never regretted it. Today they own almost every professional model that Nikon offers, including the D4, D3s, D3, D800, and D700.

Lights. The team uses Nikon strobes for most weddings and an Elinchrom Quadra Ranger set with modifiers when they need more light. They also use Roscolux gels, depending on the environment and the look they're going for.

Lenses. Morgan says, "Our primary lenses (in order of most used to least used) would be: 24–70mm f/2.8, 70–200mm f/2.8 VRII, 85mm f/1.4G [dubbed "the world's greatest portrait lens"], 105mm Micro for jewelry and ring shots, and the 14–24mm f/2.8. The 24–70mm is my primary lens of choice, and I almost always have it on one of my cameras throughout the wedding day." Morgan says this lens is especially useful in tighter corners when she needs to capture a wider scene. The zoom allows her to remain mostly inconspicuous.

Computers. "Believe it or not, we are actually a PC-based studio! Amir used to build PCs in college, so he's custom-built all of our computers and servers to be optimized for Adobe Photoshop and Lightroom." She says that they get a lot of 'guff' from their friends in the photography community for being PC users (all in good fun, of course), "but at the end of the day, we know that our PCs perform just as well as Macs — and are much easier to customize and service as needed."

Software. Photo Mechanic, Lightroom, Photoshop, and InDesign account for nearly all of the studio's postproduction work.

lighting and beginning to incorporate it into my own work.

"Colorado-based photographer Steve Stanton was actually a childhood friend whom I got back in touch with when I realized he was doing professional photography as well. Steve was an inspiration to me in so many ways—creatively and as a friend who was also in the early stages of taking his business to the next level. I liked to call Steve 'the idea man'; he was, and is today, always looking ahead. Steve introduced me to Ben Chrisman's work a few years ago, and I was immediately drawn to his photojournalistic style. His images were so impactful and really resonated with me. I ended up attending a workshop that he was a part of in London and attribute that experience to significant growth in my work."

Just Who Are You?

It is important to know your own style. It's a form of knowing yourself. On that topic Morgan says, "Though I have a background in fine arts, as a wedding photographer, I've definitely gravitated toward journalistic work. Genuine moments can never be repeated, and I think that's why documenting them never gets old for me. If I can combine interesting light and a unique perspective with a once-in-a-lifetime moment, then I've struck gold. I'm addicted to the rush—the momentum and the challenge of documenting artistically in such a fast-paced environment."

Morgan's passion to document these moments for their clients has a lot to do with her views on relationships. "My husband and I are both close to our own loved ones. As wedding photographers, we share a sense of responsibility to capture as much as we possibly can so our couples can treasure that day with their family and friends for a lifetime."

Favored Techniques

During the "getting ready" part of the day, when there is more time to play with light and angles, some of Morgan's most-used techniques are framing and the use of low-key lighting. "Framing my subjects is one of my favorite techniques to add interest to an

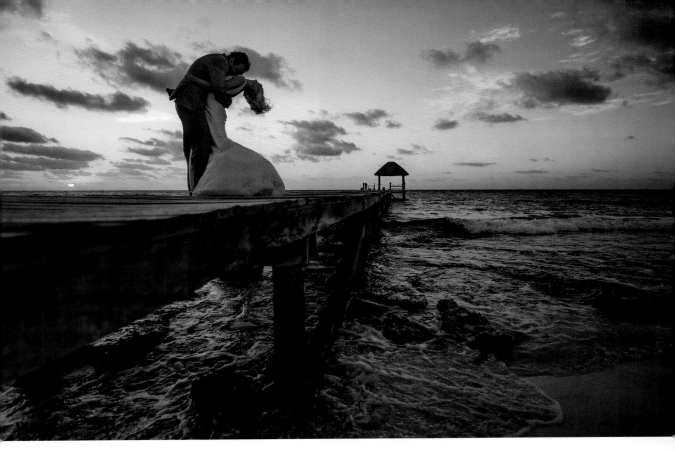

otherwise straightforward scene. I want to create context and depth by layering my images with other subjects or objects in the room that give a sense of place and time. If a bride breaks out in laughter, rather than simply capture a clean shot of her face, I will quickly source the reason (generally a person) for her mirth and position that person in the foreground of the image and frame the bride so that the photo has context. The bride may remember why she was laughing during that image if I've captured enough clues. Why does it matter? Because it gives the image meaning and will incite emotions down the road."

Another way she likes to frame her subjects is by shooting through interesting objects or textures to create mystery. This can separate the subject from an otherwise "busy" space, create visual interest in the gallery, and/or just get her creative juices flowing.

Morgan also likes to preserve as much of the mood of a given situation as she can without compromising image quality. This is much easier in a space with mixed lighting, such as a hotel room.

Low-key lighting is one of her favorite techniques in these situations; she deliberately underexposes the subject, allowing the action to be lit by subtle rim lighting coming from a lamp, a window, etc. It's important that these images have a full tonal range—so even though the subject is somewhat "shaded," there is still plenty of detail in the shadows. The light source adds contrast to the images and creates a complete tonal range. She explains, "I refer to these images as 'moody' because they tend to evoke feelings of nostalgia and reflection."

During the reception, where there is generally lower lighting and more activity to capture, one of her favorite techniques is off-camera flash. Wireless triggers like PocketWizards simplify the process of controlling a dedicated light that is not hot-shoe mounted. Correctly balancing off-camera lighting with ambient lighting is one of the most important aspects that make its use successful. That balance of light sources has not been achieved without considerable experimentation.

"With much trial and error, I've learned how to use off-camera strobes to complement and heighten moments during the reception without overpowering the ambient light," says Morgan. "Throughout nearly every reception I shoot, I switch between using a mix of on- and off-camera light, and simply off-camera light alone, depending on the look I am going for. The angle of the off-camera light provides a number of creative opportunities, so I'm constantly changing my position around the dance floor to maximize back-, side-, and front-light at a variety of lighting angles. I love using flare when appropriate to create a sense of drama during an important dance, toast, or other key moment."

One of the most important things Morgan draws on during the wedding day has nothing to do with equipment. As a documentary photographer, *patience* is critical to successfully capturing a moment

unfolding. Any capable photographer can capture a moment if they are watching for it, but it takes a patient eye to hold out for an image with real impact. She says, "As I've become more practiced in documentary photography, I have learned to anticipate the moment and where it will lead. This intuition is in no way foolproof, but it's important to trust. I generally have a sense when a moment is going to unfold into something special. It takes patience and faith that it will be worth waiting for even when there are seemingly hundreds of other important moments to be capturing simultaneously. I am always weighing what I may be giving up before committing to a shot. Having a second shooter can be liberating in these situations because you can take the extra couple minutes you need to wait for your shot to line up while another pair of eyes is covering the rest of the room. At a wedding, though—unlike being on a real-world photojournalism assignment—sometimes you just have to let the shot go because other shots have to take precedence."

Wedding Photography Philosophy

"Even before I understood what wedding photojournalism was, I believed that the role of the wedding photographer was to document genuine moments and emotions—the beauty, spontaneity, tears, and even the chaos. I still believe that this is my primary role as a photographer and it's what keeps me going at the end of a very long, physically draining day of shooting. But I can't say I'm satisfied at the end of the day if I come away from a wedding with nothing but a collection of documentary photography. While this is the most important aspect of my job, creatively speaking, it's not enough. For me, wedding photography is about having a balance between documenting and imparting my own artistic interpretation of the day. Our clients hire us as much for our technical ability as our creative vision, which is translated through photographic techniques as well as our processing style.

"Wedding photography is also about being able to excel in more than one style of shooting. At

any given moment, it's my responsibility to be able to switch gears from documentary photography to portraits, for example, without compromising the quality of the work. In order to accomplish that, I have to know my craft inside and out and be prepared for each individual wedding day. In addition to the obvious equipment preparation, I need to identify creative opportunities at each location and understand time constraints and client expectations in advance—as well as have the confidence and professionalism to deliver exceptional work under stressful circumstances.

"On a more general level, I've always believed that wedding photography should be beautiful. This might go without saying, but all too often I see work that celebrates some of the more unflattering aspects of the wedding day. This is definitely a stylistic preference but, in my opinion, it's my job to make my clients look their best and feel good when they view their photos. Obviously, some things are out of our control, but I believe there is always a way to shoot 'beautifully' regardless of the subject or venue.

"Lastly, wedding photography should be happy! Especially the reception—it is a *party,* after all. Prospective clients often tell us that our weddings look like so much fun. This is not because we have unusually wild weddings, but rather because we focus on capturing the day in a positive, energetic way. We look for smiling/laughing guests when shooting candidly during the ceremony and reception and do our best to wait for moments to develop completely, rather than catch an awkward in-between shot."

Logistics

According to Morgan, a certain amount of planning goes into every wedding—reading through the timeline, being clear on locations and logistics, and having all the studio's questions answered ahead of time. If they're working a destination wedding or shooting at a new venue, there is usually additional planning involved, such as determining the best angles and portrait opportunities, plus choosing locations for the "first look" (if there is one) and formal portraits before and after the ceremony, etc.

Morgan also pays close attention to where the sun will be rising/setting, making sure she is aware of and prepared to shoot in the backup location should an outdoor ceremony be rained out.

Morgan is cautious about time and often maps out shots in advance. "I like to have a couple portrait ideas in advance, even for venues that we have shot at before. Oftentimes, we only have five or ten minutes with the bride and groom for creative portraits. Our goal is to create a variety of unique images in that short time span. Amir usually takes care of planning out our supplemental lighting if we're in a situation where we are outdoors or are in an unusually complex location. Aside from being prepared, we try not to over-plan. Weddings can be incredibly unpredictable, and we know that spontaneity can result in some of the most amazing shots of the day."

A lot of the team's "planning" happens minutes or even seconds before something is about to take place. Morgan says, "We have to stay on our toes, communicate, and put everything else in our minds aside to be able to respond creatively in such a fast-paced setting. I love shooting alongside Amir because we know each other's strengths and preferences so well that we can collaborate easily in the moment."

Postproduction

Once the collection of images has been culled by Amir and finalized by Morgan, the RAW files are handed over to one of the studio's editors. Each image is processed thoroughly in Lightroom by the editing team and then reviewed by Morgan.

This phase means a lot to Morgan, who says, "Postproduction is such a personal and stylistic aspect of wedding photography and I can't help but get involved—even with the most competent editing team working under me, I still make adjustments to the gallery. Call me a perfectionist, but processing consistency and color are as important as the quality of the images themselves."

Once the images have been fully processed, they are organized and renamed in Photo Mechanic, then delivered to the clients via a private digital gallery and web-based slide show.

Working Successfully

Professionally, Morgan believes the basis of being successful as a wedding photographer comes down to making your clients happy and consistently producing great images. "I'm always pushing myself to take better photos. Every time I pick up the camera, I have the chance to take the best photos of my life. Approaching each wedding this way, no matter how grand or exotic the event may be, is what has helped our work stand out. Our couples can see the difference in their photos, even if they can't pinpoint exactly what it is, and they believe we're worth raving about. That alone is the biggest compliment of all, and it justifies the time and energy we spend honing our craft."

Photographically, the Morgan Lynn Photography team works hard to separate themselves in not just one individual aspect, such as portraiture, for example, but rather as a whole. This involves consistently showing images of great moments coupled with clean lines, vibrant colors, and tones

The Next Ten Years . . .

Morgan's goals for the future are changing slightly as Amir and she get ready to welcome their first child. She says, "Raising a family is definitely going to play a role in the direction of our business over the next ten years. While there are plenty of unknowns, one thing we do know for sure is that we plan to keep growing as photographers and a studio as a whole. We plan to launch an associate photography studio in the coming year and reach a piece of the market that we have currently priced ourselves out of. I don't have aspirations to transform Morgan Lynn Photography into a large studio and prefer to maintain the same intimate, boutique-style business that we have today. I expect that we will be accepting fewer weddings in the coming years to make time for family and we may find ways to expand on our presence in the commercial photography community."

that are classic, not trendy. Morgan says, "Every time we put our work out there, we hold ourselves to these standards."

There's really no shortcut when it comes to success in this industry. The keys are hard work and dedication to consistency and client satisfaction.

MRK Palash
A New Culture in Bangladesh

Mohammad Rashed Kibria Palash (*a.k.a.* MRK Palash) is one of Bangladesh's most popular and well-known wedding photographers. His upscale, progressive studio La Creation Wedding Photography & Cinema (better known as La Creation) prides itself on offering the Bangladeshi bride a modern alternative to the country's very traditional studios. MRK holds bachelor degrees in commerce and photojournalism from the South Asian Media Academy. His approach is to capture the emotion and the details of the day using a blend of photojournalism and fine-art portraiture – and he is never content to do the same thing over and over. He plans to take La Creation to the international level, branching out into Europe and eventually hosting wedding photography schools in both Bangladesh and Europe. MRK's success is rooted in his passion for his craft and his love of hard work. (*www.facebook.com/LaCreationWeddingPhotography*)

MRK Palash lives in Bangladesh, the eighth most populous country on earth with a population of 160 million people. There, he founded an organization named "La Creation Wedding Photography & Cinema," better known simply as "La Creation," that represents the young photographers who have created a revolution in the Bangladeshi wedding photography industry.

The Early Days

MRK recalls, "Before becoming a professional photographer, I was a student at university. I graduated with a Bachelor of Commerce degree. When I finished my final exam and was waiting for my results, my brother-in-law, Mr. NH. Iqbal, who is also a photographer, suggested I work with him in studio photography. It was a good opportunity

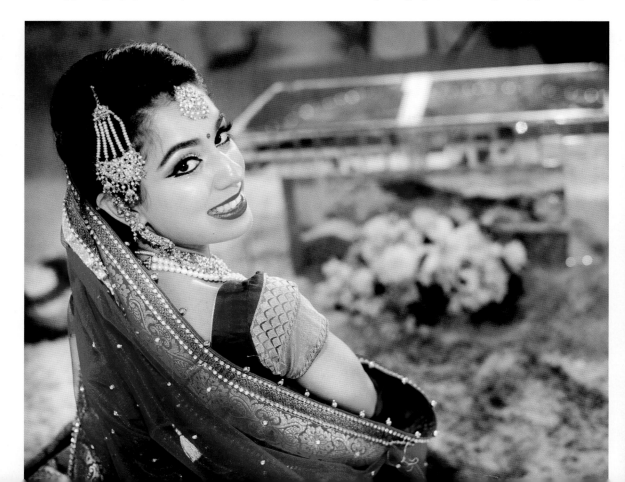

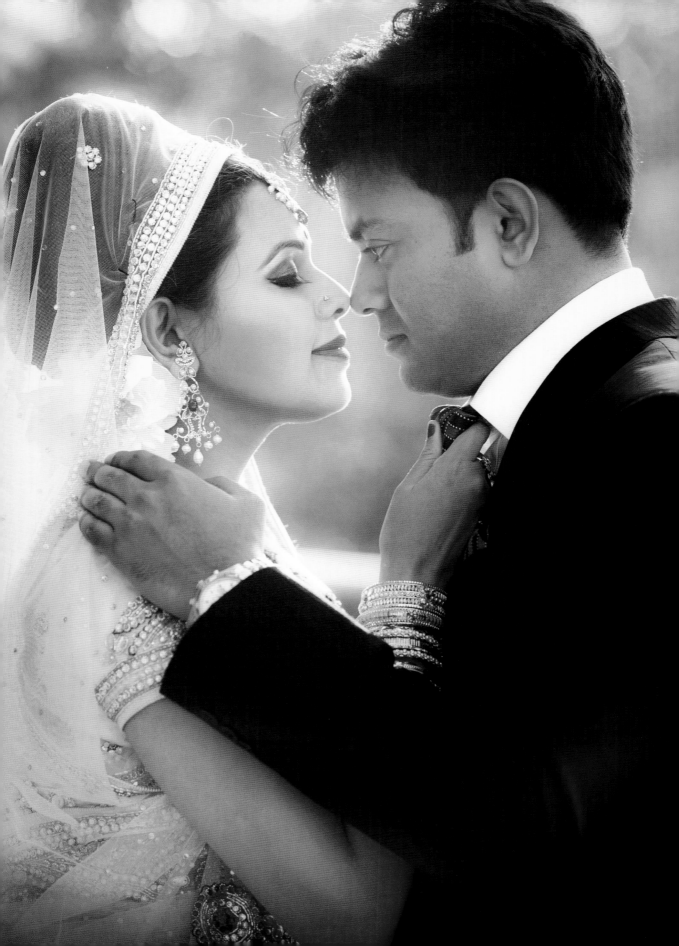

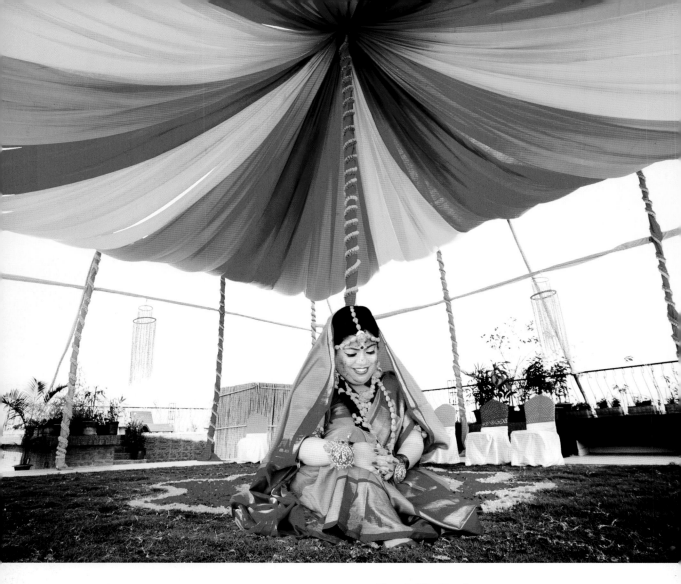

for me to learn photography, so I joined him. I learned the basics of studio photography, but I felt the need to learn more about the technical aspects of photography. So I soon applied to the South Asian Media Academy in order to get a Bachelor of Arts degree in Photojournalism.

"My education not only prepared me to become a good photographer, but it definitely prepared me for what I am doing now. It was the most resourceful base for my learning the craft and business of photography. I am very proud of the fact that my entire tuition at the South Asian Media Academy was paid for with wedding photography profits."

About His Business

"My company, La Creation, was founded in September, 2011, and the company has already covered 350 weddings," says MRK. "Before founding La Creation, I was a freelance wedding photographer. At that time, I felt that if I had an organization, a company, then I could handle my clients in a more professional way. When I was a freelancer, I did not maintain any official contracts with my clients and our deals were made verbally."

"Since founding La Creation, I have maintained certain official rules and practices. Clients can see my work on my company's Facebook page and our

website and then contact me. Since our fees and prices are listed, I do not need to bargain about prices with clients.

"I work with a fine staff. Jahir Raju is a photographer and graphic designer. Rashel Khan is a cinematographer, Rakib Ahamed Baabu is also a photographer, and Mahabub Alam is a technical assistant. When we are super busy, we recruit freelance photographers and cinematographers who are familiar with our style at La Creation. Also, we employ my assistant Jahir Raju for picture editing."

The "La Creation" Approach

Says MRK, "Nowadays, we are much more experienced at photographing Bangladeshi weddings—but as a photographer I sometimes felt bored taking the same kind of pictures all the

Equipment

Here is a rundown of the gear used by MRK Palash and his company in their wedding photography:

Cameras. Canon EOS 650D [Canon Rebel T4i].

Lights. Assorted Canon Speedlights: Canon 580 EXII, 600 EX-RT, 270 EX-RT, etc.

Lenses. Canon 50mm f/1.8, Canon 50mm f/1.2 and f/1.4 lenses, Canon 24mm f/2.8, Canon 17–40mm f/4, Canon 24–70mm f/2.8, Tokina 10–17mm f/4 fisheye. MRK prefers fast, prime lenses as they free him to shoot in all kinds of light, including very low light.

Computers. Apple MacBook Pro (15-inch), iMac 21.1, Windows PCs.

Software. Lightroom, Photoshop, Portraiture and Topaz plug-ins for Photoshop, Nik Software plug-ins.

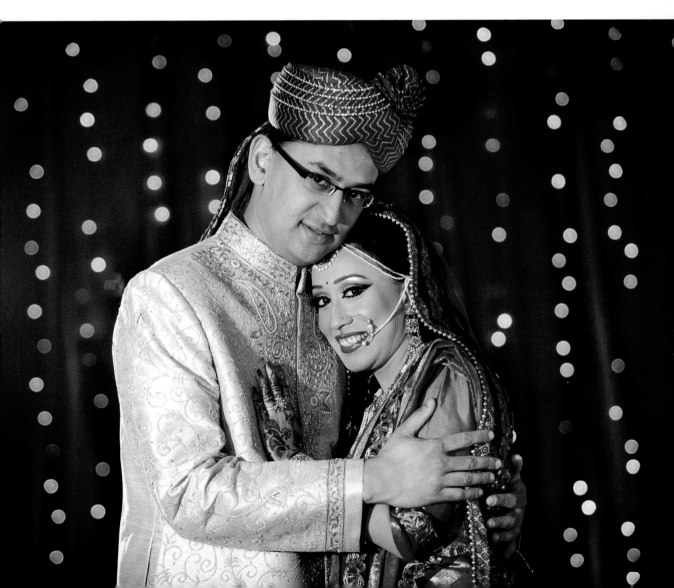

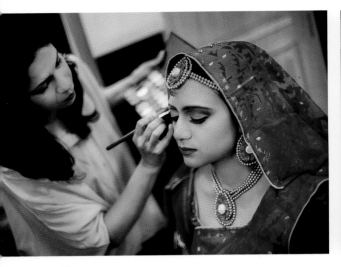

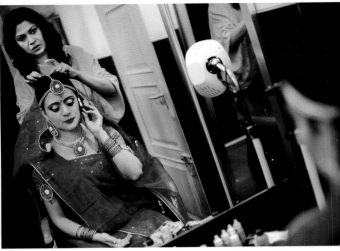

"We created an advertisement that said, 'If you want, then your photos could be like this.' When clients see these pictures, they get motivated to take outdoor pictures, which opens up more creative opportunities."

time. That's why we push our clients to go for outdoor photo shoots and different ideas. But in Bangladesh, people are so very traditional. They worry about breaking the customs. So we created an advertisement aimed at couples that said, 'If you want, then your photos could be like this.' When clients see these pictures, they get motivated to take outdoor pictures, which opens up many more creative opportunities."

"La Creation's approach is to capture the couple's story—the emotion and the details. We work closely with the client to create natural photographs that reflect the character of the bride and groom. Our approach is relaxed and flexible, making the whole experience as hassle-free as possible. The staff tries to be invisible, leaving the couple to enjoy their day. Our style is primarily documentary with creative couple shots. We make wedding photography with a fun, photojournalistic style. We try to elegantly capture the story of the weddings we photograph.

"Although we have a studio, usually we do not get the chance to use it. In the Bangladeshi tradition, clients are not usually interested in doing indoor studio photography. Rather, they prefer on-location photography."

MRK's Philosophy

MRK's philosophy of wedding photography is to create a blend of photojournalism and fine-

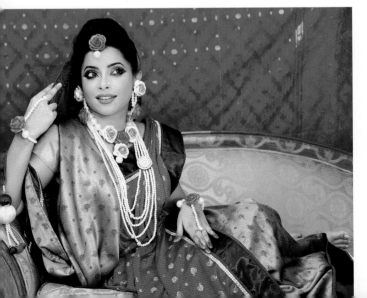

art portraiture. "It is a privilege to be allowed to document the whole day like a photojournalist from the bride getting ready, to the ceremony, to the first dance, until the party ends, and anything that happens along the way," he says.

"I am passionate for portraits, documentary photography, photojournalism, and the different elements of fashion photography—glamour, sensuality, and elegance. This is why I perceive documentary wedding photography as a world of infinite artistic photographic possibilities. It is an art by itself.

"Weddings are a personal life choice and a social happening. They are important moments in our lives, and as an artistically engaged photographer, I feel privileged to witness those moments and document them through my lens.

About His Name

"You have asked me why my first name is MRK. Really, it is not. My full name is Mohammad Rashed Kibria Palash. In 2008, *The New York Times* selected one of my photo stories for publication and they published my name as "MRK Palash." I was very concerned about this at the time, but soon found it is a very popular shortcut that people seemed to like. So, I am now happily MRK Palash."

"My job consists of telling a story—the story of the bride and groom, the day, their family and friends, and all that goes on. I like to work in an unobtrusive manner, looking for those natural, unguarded moments to unfold. I am always looking to provide creative, fresh photography—those moments, emotions, and expressions that will be their future wonderful wedding-day memories."

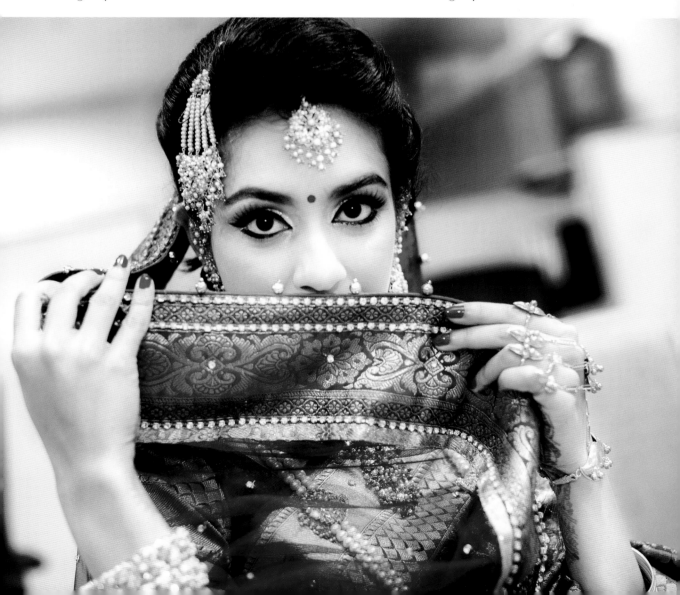

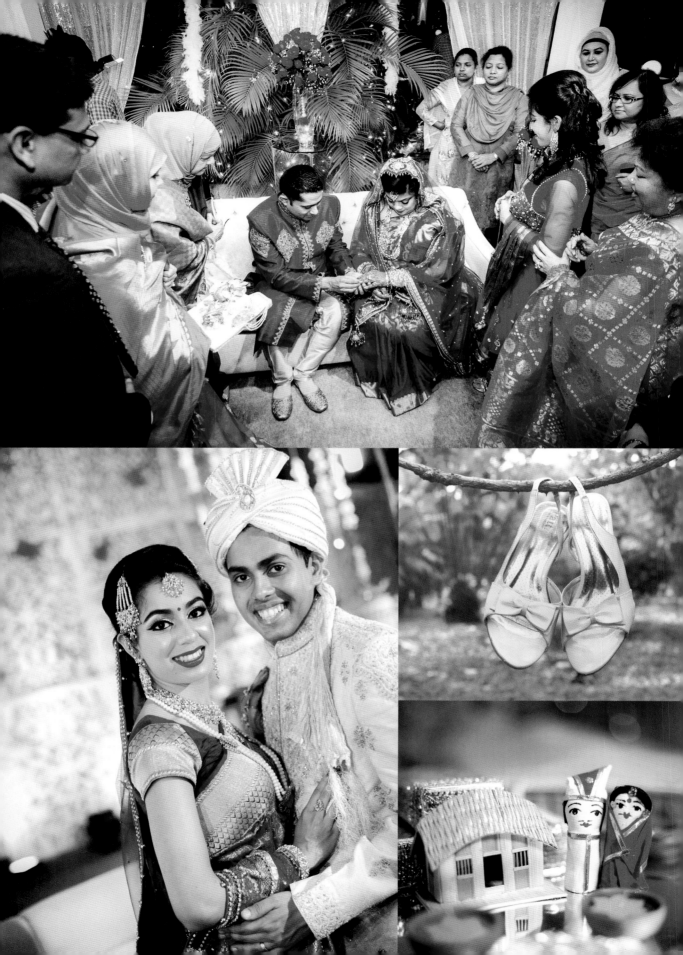

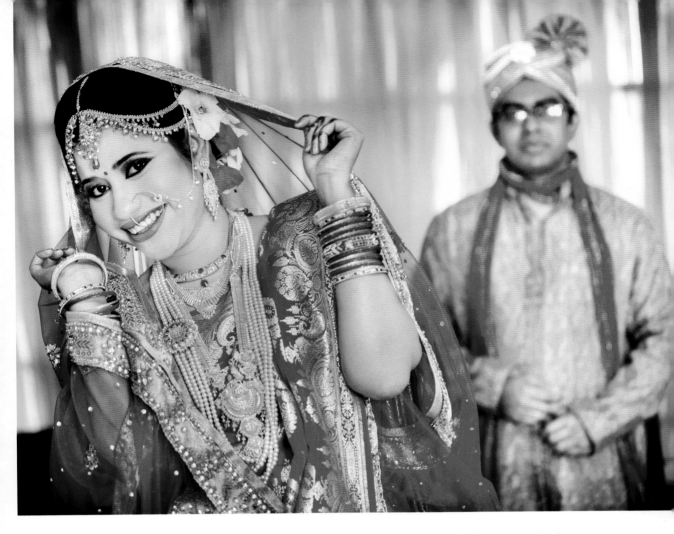

La Creation images are clean and crisp—but also romantic, funny, and emotional. MRK and his team are critically acclaimed for developing a unique style of wedding photography. They pride themselves on being not just good photographers but also artists creating unique and expressive imagery.

Keys to Success

La Creation is doing phenomenally well for a startup company—and MRK has some definite opinions on the company's success. "I believe my academic training from the Pathshala Photography School, which is part of the South Asian Media Academy in Bangladesh, and my experience in documentary photography are two key elements for our success. Other than that, of course, my success relies on hard work and our passion and dedication to wedding photography. I believe my style of photography, along with ten years' experience in the wedding photography sector, separate me from the competition."

Inspiration

"My source of inspiration and creativity lies in my passion for photography," says MRK. "When I deliver pictures to my clients, I get an instant response from them about my work and how they like it. It motivates me to improve my skills as a wedding photographer. The more clients there are who like my style of photography, the more it sells itself to brides."

MRK is also a huge fan of Jasmine Star and has been influenced by her work and attitude. "I was very much impressed reading her blog and her intention

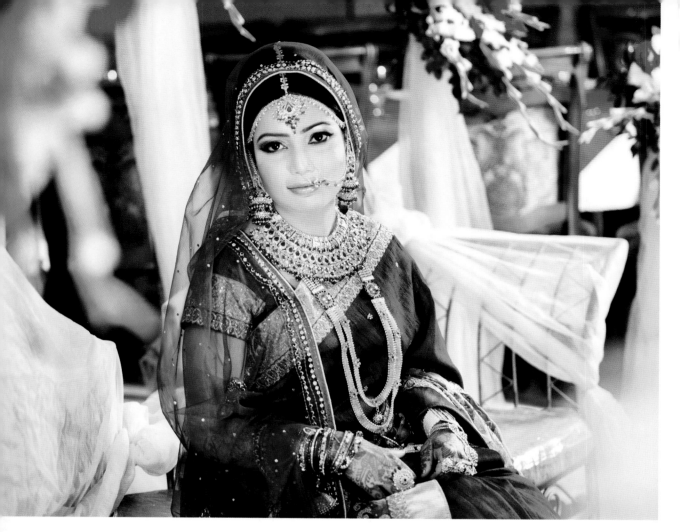

to teach young wedding photographers. She is a dazzling bride turned wedding photographer. Instead of hiding in a secret professional photographer's club, she opens up to her fans and gives out tips, photography lessons, and photography business strategies on her blog."

The Soft Sell

MRK's sales pitch is quite interesting and goes like this: "Your wedding photographs stay with you for a lifetime. We know how special this day is. Please don't think about booking us now. Take your time. As you think about what's important to you, try to see photography as an art and feel the butterflies inside you as you take your imagination on a journey with us." The sales pitch continues, "They say a picture is worth a thousand words, and we agree. By now, you're probably feeling the excitement of your wedding day, and we hope that you enjoy your journey with La Creation. If you choose us for your special day, you will soon realize our passion for photography and love for life. As you visualize all the beautiful moments on your wedding day, imagine your wedding story told in images that allow you

to re-ignite the passion, excitement, and intimate moments that you both shared on your special day. On what is always an incredible day filled with excitement, we will capture the breathtaking bride, the dashing groom, the spectacular bridal party, and the proud family and friends unlike any other photography team."

Favorite Techniques

MRK has a couple favorite techniques to share. The first is what he calls the "top shot" on brides. "It is a very beautiful angle, provided you can find a good vantage point from which to make the shot—like a balcony. It is a slenderizing angle from which to photograph the bride and/or bridal party, which will be appreciated, especially if the bride is a little on the heavy side. The overhead angle creates a perspective that optimizes the face, neck, and shoulders, and hides everything below the shoulders. It is also a very uncommon viewpoint. Brides usually love this angle."

> "The overhead angle creates a perspective that optimizes the face, neck, and shoulders, and hides everything below the shoulders."

Since the faces are all on approximately the same plane, MRK usually does this overhead shot at f/2.8. MRK says the top shot helps brides discover their "hidden beauty."

Another technique MRK likes to experiment with is bouncing the flash at unusual angles. Depending

Postproduction

MRK does the majority of the studio's postproduction so as to preserve what he calls his "signature style." This is also the case for special events, where a specific style of retouching or effects are called for. As needed, he will also delegate postproduction work to assistants, but he supervises their efforts.

on the angle and surface you bounce the light from, this softens the light and creates good texture and modeling. Bouncing the light off of a side wall produces beautiful portrait light—but since the flash can be set to virtually any angle you can think of, there are many other opportunities for creative images with a single speedlight.

"Sometimes, I'll add color to the reflector panel of the speedlight, which tints the bride's face a different color. Or sometimes I'll let the colored flash mix with the available light for an unexpected result. There are no rules. Sometimes I'll even flip my camera upside down and let the flash come from beneath the camera. This is truly an unexpected type of lighting," says MRK. "Bounce flash can produce some very interesting textures."

No Room for Error!

"A photographer covering a press event only needs to get a few good shots. A photographer who is shooting

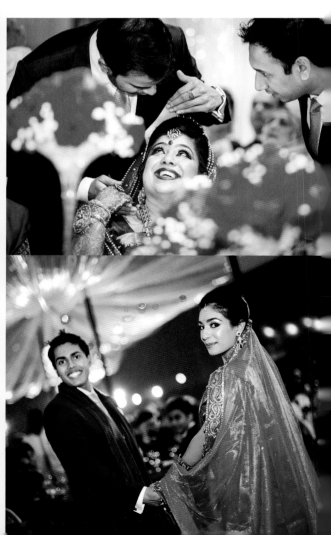

a personal project can take his or her time and come back many times to re-shoot the subject. An architecture photographer can decide the day and time of the shoot and reschedule if the weather conditions are not favorable. An advertising photographer might have pressure from the agency and the client but will often have a team of assistants and the time required to get to the right shot. A corporate photographer can ask a company director for a second sitting to get a portrait just right. The worst that can happen is that they might lose a client," says MRK. "A bridal portrait photographer can even ask the bride to get dressed up again for re-shoots. However, a wedding *event* photographer has no room for error. Events cannot be replayed—especially when it's as personal and unique as a wedding!"

In Ten Years

MRK's goals for the future are lofty. He wants to take La Creation to an international level. He would also like to start wedding photography schools, both in Bangladesh and in Europe, teaching those who want to learn his unique style of wedding photography. MRK says, "In ten years I would like to see La Creation established in the European market."

> "Sometimes I'll flip my camera upside down and let the flash come from beneath the camera. This is truly an unexpected type of lighting."

Dave and Quin Cheung
The Ultimate Hopeless Romantics

Dave and Quin Cheung are a married team of visual artists whose wedding photography and album designs have won numerous international awards. Their business, DQ Studios, is well known for edgy, fashionable portraits created with small flash—a lighting solution that lets them design their amazing images virtually anywhere. Says Dave, "With global accessibility, we've grown from a small-town clientele to shooting weddings in South America, the Caribbean, Asia, Europe, and beyond." They are acclaimed photo-educators as well as the co-creators of the Motibodo Lightroom and Photoshop keyboards. With their two sons, they make their home in Calgary, Alberta, Canada. *(www.dqstudios.com.)*

A Mobile, Full-Service Studio

Before founding DQ Studios, Dave Cheung spent ten years running his family's piano business. His former retail experience gave him a good understanding of the overhead expenses associated with a retail space, so it was easy to decide not to invest in a static studio (they do, however, maintain a client-meeting space). Going without a camera room also aligned with Dave and Quin's personalities. Says Quin, "We both bore easily. The thought of shooting in the same space every day did not seem appealing."

Therefore, instead of opting to be confined by studio walls, they decided to invest in a "portable" studio—lights and gear that they could take anywhere

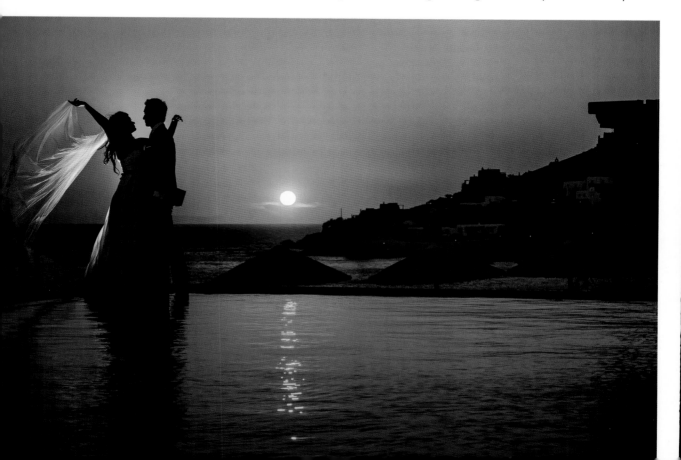

around the world. "This gave us the freedom to create any look, from high-fashion, to edgy, to editorial, turning night into day and day into night in any location our clients take us to," says Quin.

Knowing they would not have a studio at their disposal, DQ had to find tools and techniques that would allow them to light *anywhere*—from their backyard to India—all with gear that fits into their carry-on luggage. The team pursued the concept of a mobile, full-service studio using portable flash. "Thankfully, advances in technology have made our 'gear' lives easier, but we continue to push the boundaries of what's possible with simple on-location tools," asserts Quin. "We want to be able to create dramatic portraits *anywhere*."

She continues, "Whenever possible, we love to tie the environment in with our subjects, whether it's the venue where they got married or the restaurant where he proposed. Often, our couples come back to us after the wedding to have us photograph their pregnant bellies or their growing kids. Rather than use a studio space, we love to bring our lights to personal homes or spaces where our families are most comfortable and have the fondest memories."

Equipment

"Our gear list is ever changing," says Dave. "I am a self-professed lighting geek, and am thankful for Quin's patience as I test out different gear. I'm always on the lookout for the best tools and techniques to deliver amazing results with less weight, fuss, time, and effort." Here's what they currently use:

Cameras. Four Nikon Df camera bodies. Standardizing on a single camera body makes shooting and battery/memory-card management easy.

Lights. Four Phottix Mitros+ strobes, three Einstein monolights.

Lenses. "We choose to shoot with primes and prefer to 'zoom with our feet.' We pack light, have great optics, and force ourselves to frame with care," says Dave. In their lens kit: 24mm f/2.8, 35mm f/1.4, 35mm f/1.8, 50mm f/1.4, 50mm f/1.8; 85mm f/1.8.

Computers. Mac Pro and iMac 17-inch workstations, MacBook Air (13-inch) laptops for travel.

Software. Photo Mechanic, Lightroom, Photoshop, Final Cut Pro, Motibodo.

They are so successful in their approach that it's almost unbelievable—literally! As Quin recounts, "Over a decade ago, we had the opportunity to create stunning portraits at our first destination wedding. Somehow it got back to us that other

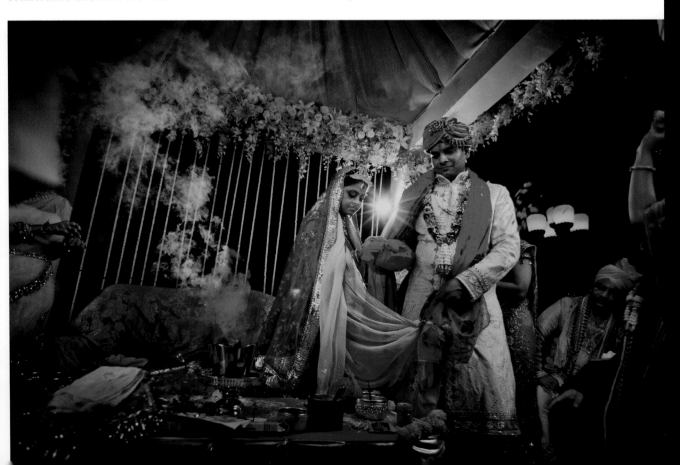

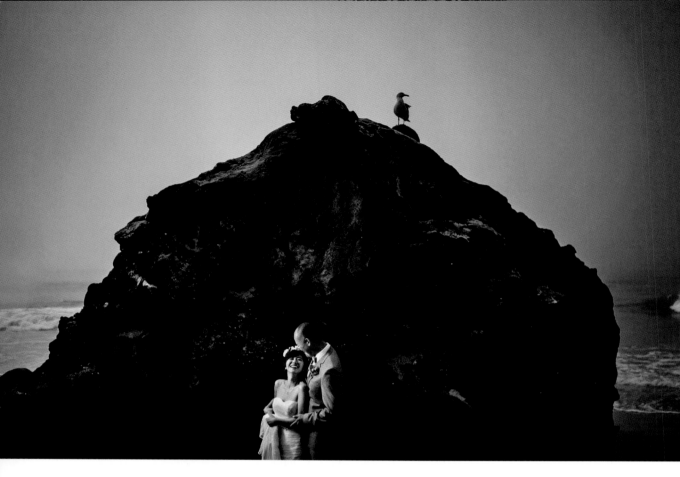

studios were saying we Photoshopped our couples into the beautiful scenes of an amazing ocean sunset! We took it as a compliment—and at the next local bridal show, we asked several of our former brides to show off their albums so there would be no doubt about the authenticity of the images."

A Unique Perspective

Dave and Quin truly believe that, as photographers, they shoot out of who they are. Faith, family, and life experiences all collide to create their unique perspective and affect them deeply in conscious and subconscious ways, according to the couple.

Quin talks about the creative force that is in each of them: "For us, our faith in God, deep respect for each other, and love of family is a huge driving force and fuel for our creativity. We were both musicians before becoming photographers, so having a creative outlet has always been necessary. We're thankful photography has allowed us to not only release our creative energy but also contribute to the marriages of our clients."

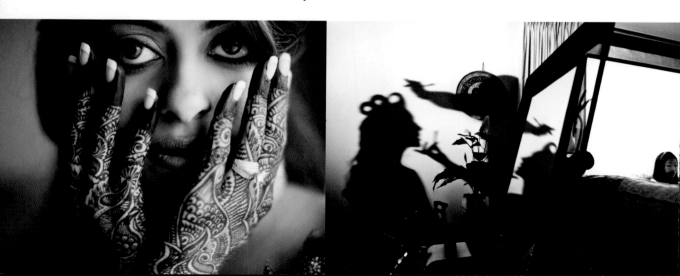

Timing Is Everything

Dave and Quin feel that timing has contributed to their success. "We actually consider ourselves horrible marketers, but we are blessed to have a busy studio. We were fortunate to come into the industry at a time when the Internet and digital photography were just taking off," says Quin. "The Internet has always been the perfect platform for photographers to share work. With global accessibility, we've grown from a small-town clientele to shooting weddings in South America, the Caribbean, Asia, Europe, and beyond. Truly, the Internet makes the world our studio."

Postproduction

In the early days of DQ Studios, the couple shot 35mm and medium format and did their own darkroom developing and printing. When they switched to digital, they couldn't let go and continued to personally postprocess each and every image.

"We are the Asian sweat shop," says Quin laughingly. "We're huge control freaks, as photographers and as photo-retouchers. We have tried to train people under us to retouch, but we have

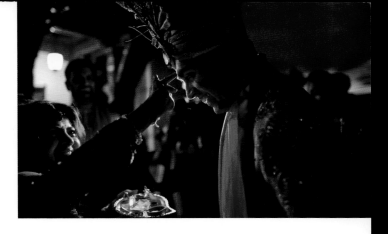

"With global accessibility, we've grown from a small-town clientele to shooting weddings in South America, the Caribbean, Asia, Europe, and beyond."

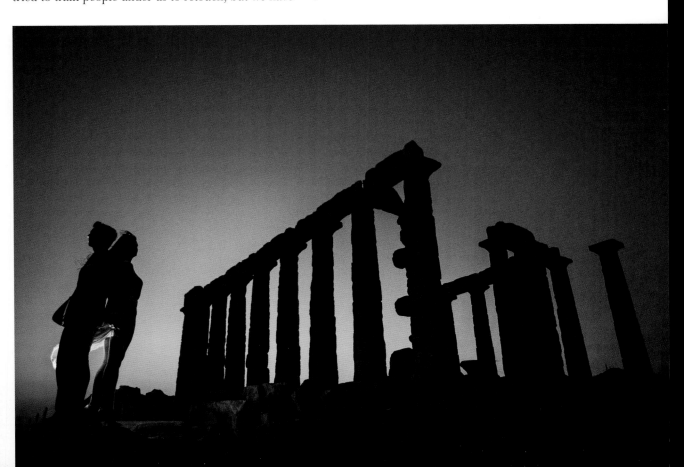

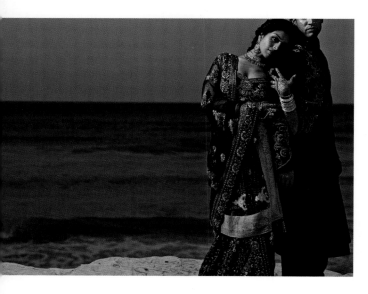

Mac keyboard and converts it to a matrix of software processing commands that work in Adobe Lightroom and Photoshop.

Their overall workflow is shared. Dave selects images using Photo Mechanic. Quin has a better eye for color, so she does the Lightroom and Photoshop work. They both design their signature albums. Dave takes care of client galleries and the archiving of client data. Quin completes all client orders and handles the contact with them (e-mail, phone, etc.).

Keys to Success

Like the other photographers in this book, one of the questions I posed to Dave and Quin was what they believe are the key elements in their becoming such a big success. Quin's response was, "It's funny for us to read this statement because 'a big success' is probably the last thing we see ourselves as—especially when we stop to look at all the sublime talent emerging in the industry. In an industry as competitive as wedding photography it's hard not to look around and compare yourself to other photographers—keeping up with the latest poses, props, actions, and toning styles. It's overwhelming. We've learned that for us,

come to understand that the retouching is also part of our art. We personally complete our vision using Lightroom and Photoshop."

This decision made for a very labor-intensive, post-shoot work schedule, so they created Motibodo keyboards (www.motibodo.com) out of their own need to retouch images faster but without compromising image quality. The Motibodo keyboard is a "skin" that mounts atop a standard

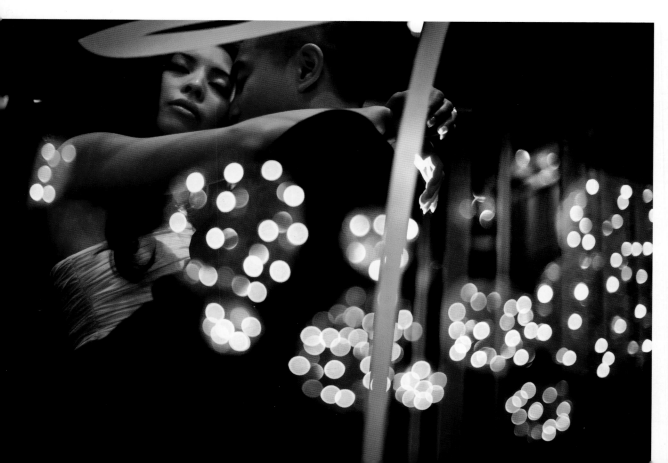

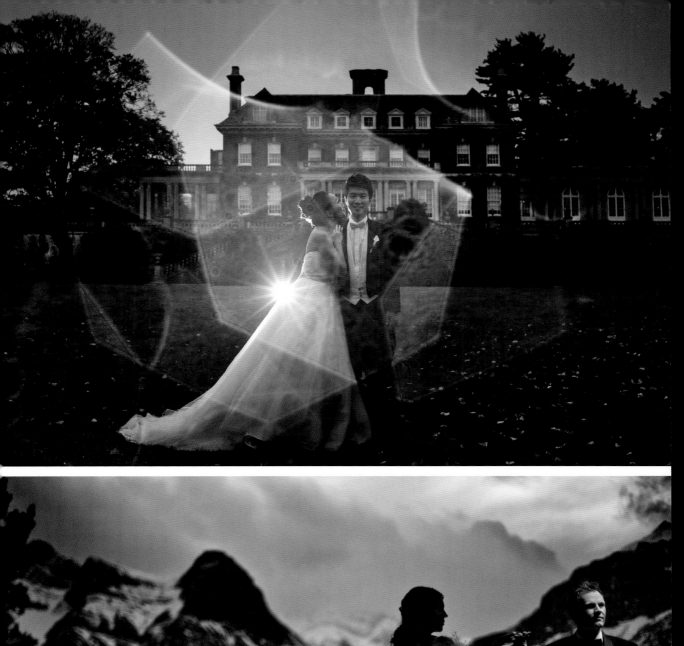
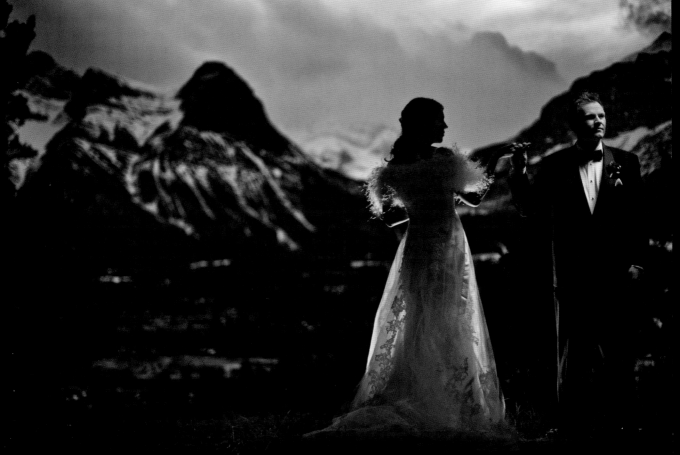

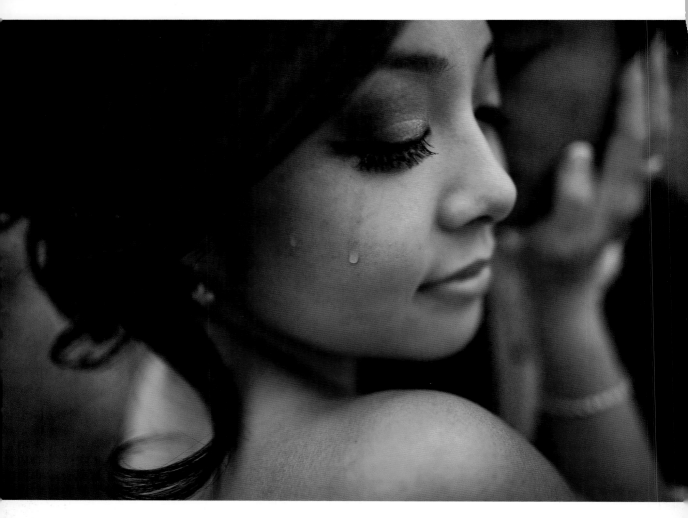

we thrive when we stop looking at what everyone else is doing and just focus on creating images that make us smile and make our clients happy."

Significant Influences

That's not to say, of course, that the couple isn't eager to learn from those who are pushing the creative and professional boundaries of wedding photography. Dave says, their most significant influences include Huy Nguyen, an influential photographer and educator based in Washington state, for his documentary work ethic. They also admire Jerry Ghionis and Yervant, two Australian master photographers who are well known for their dramatic posing and lighting.

Finally, they cite the influence of Joseph Victor Stefanchik (known as JVS), a Washington, DC, wedding photographer who is widely known for his creative mastery of off-camera flash.

"Our style has emerged from a melting pot of these very different influences," says Dave. Of course, their style is evolving on its own, as well. Says Quin, "We really don't like to confine ourselves to certain labels since a wedding requires that you use many techniques—journalistic approaches for moments and emotion throughout the day, traditional photography

for family portraits and groups, and fashion-forward and fine-art shooting for couples' portraits. In order to be better wedding photographers, we must constantly push ourselves to be excellent across all of these genres of photography."

Education and Training

"We have been blessed to have many factors play into making us the photographers and businesspeople we are today," says Quin. One of those factors was their education, which they both value highly. "Being good Asian kids, we both are university-educated in other more traditional fields," says Quin, who holds a business degree in Information Management Systems and worked for Accenture after graduating. Dave has a degree in Biochemistry, which was completed as a pre-med route. "After graduating, however, he worked in the family piano business instead of pursuing a medical degree," says Quin.

Quin continues, "Although our chosen fields of study and work seem unrelated to our current passion, the experiences were pivotal, creating the

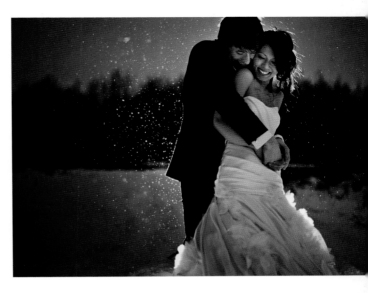

people we are and choices we make today. The university culture of learning through self-directed studies and group work, along with the trials and pressures of deadlines and exams, led to our work ethic and problem-solving abilities. Dave's background in managing the family business, with its highs and lows, helped us understand from

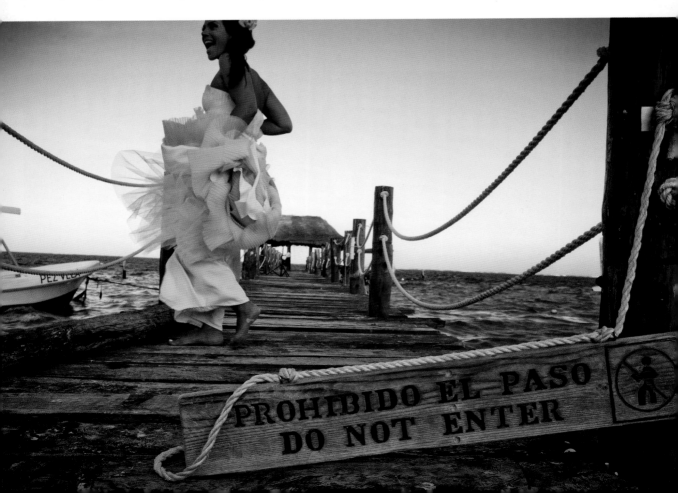

the beginning what we wanted to achieve, both personally and in our business as DQ Studios.

"For example, the piano business required a huge commitment of retail space and inventory. In many ways, we've created DQ Studios as just the opposite—we work from home and have no retail space or inventory. Our 'inventory' is our time and art. Though we work harder and more hours than in our previous careers, we highly value the incredible flexibility we've built into our business and are thankful for the opportunity to do, professionally, something that allows us to spend our creative energy to enrich the lives of others."

Essential Techniques

According to Dave, "Off-camera flash, plus creative framing, then waiting for moments to happen—these are the key things we do at our weddings. Mastery of off-camera flash allows us to light any part of the day—not only portraits, but also real moments wherever and whenever they happen. Also, we use off-camera flash to add drama and focus. It's like having in-camera dodging and burning. The bonus is it makes postprocessing easier because the image is essentially 'finished' in-camera."

> " We hope to capture images for our couples that can one day fix a fight, remind them how they love, or perhaps even save a marriage."

The Ultimate Hopeless Romantics

Quin confesses, "We are the ultimate hopeless romantics. From the very beginning, we've always said that with every wedding we shoot, we hope to capture images for our couples that can one day fix a fight, remind them how they love, or perhaps even save a marriage." Quin says that when they shoot a wedding with that philosophy in their heads and hearts, they shoot differently—better, deeper. All of a sudden it matters more. "We've become known for dramatic lighting and posing. But a wedding is so much more than that," she adds. "We're really into moments and relationships. We do our best to creatively frame shots and wait for special moments

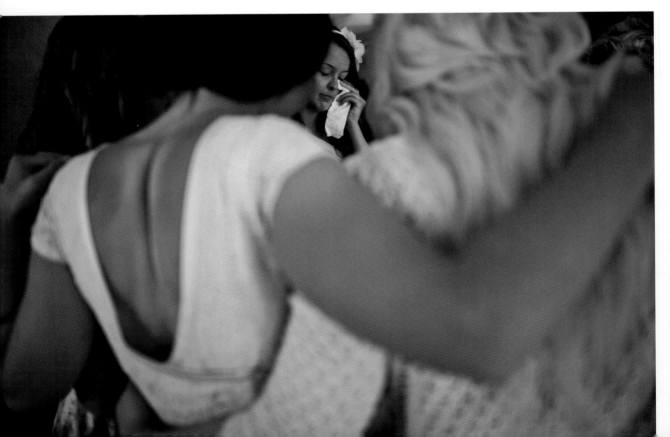

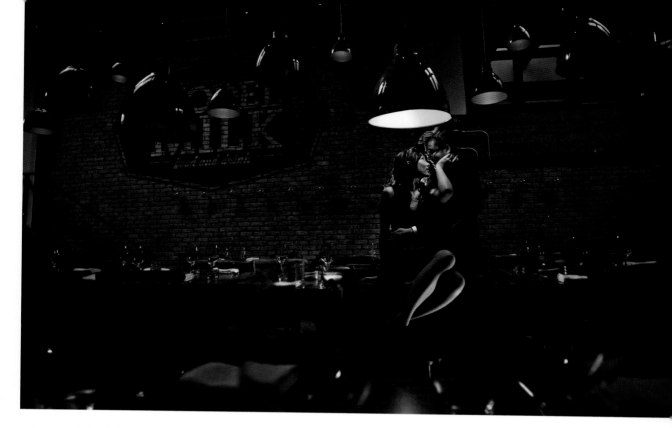

to happen. Thankfully, weddings are full of emotion and moments."

Balancing Act

Dave and Quin are opposites. Quin loves to scout locations and previsualize shots; Dave puts his efforts into preparing the gear to be ready for any situation. Together there's a synergy. They're especially thankful to have started shooting together from the beginning. Their seamless working style is a result of years of lighting for each other and working together every day. Before every wedding, they ask each other, "What are you going to do differently today?" Quin says it's a great reminder to never fall back on the safety net of only doing what they already know. She adds, "Although we have the utmost respect for each other, we're also highly competitive and strive to get an amazing shot that will make the other jealous."

"Bestomers"

"We are not high-volume shooters. We aim for fifteen to twenty weddings each year," says Quin. "For each of those couples, we strive to service them in a way that is above and beyond what anyone else—in any industry—can do for them. We hope to craft a body of work that will serve and enrich their marriage. We desire each couple to have unique products they'll be proud to show off for generations."

Quin also notes, "We've built our business this way to allow us the time and energy to truly invest in each relationship that we build with our couples." These relationships are often so close that they coined the word "bestomers" to describe the many clients who have become not only great customers but also great friends.

The Next Ten Years

Dave and Quin look back with fondness – and approach the future with the same affection and enthusiasm they bring to their client relationships. "It's been just over ten years since the day we started DQ Studios, and we feel blessed to call friends many of the couples we photographed many years ago. We've had the chance to document each stage of their lives together – to document new homes, new babies, and birthday parties, and to see their kids grow up. It's so fulfilling to give our couples this gift of capturing their life memories; ten years from today, we hope to be doing exactly the same thing."

Roberto Valenzuela
Complementing His Clients

Roberto Valenzuela is a wedding and fine-art photographer based in Beverly Hills, CA. His academic background is in economics and marketing. However, it was his ten-year career as a concert guitarist that gave him his unique outlook on how to master photography – just like you would learn to play a musical instrument. Roberto has won over seventy international awards in the course of his photography career, including three first-place finishes in print competition. Three years in a row, he was named one of the world's top wedding photographers by *Junebug* magazine. In 2013, photographers around the world also voted him onto *Shutter* magazine's list of the world's ten most influential photographers. He serves as a print competition judge for WPPI, PPA, and European organizations, as well as in the international wedding album competition for WPPI at their annual convention in Las Vegas. Roberto's private photography workshops and speaking engagements are held worldwide. His goal is to inspire and encourage professional photographers to practice their craft when not on the job – as artists in other genres must do to perform. *(www.robertovalenzuelaphotography.com)*

Style

Asked to describe his style, Roberto says, "There is an art to using the physical elements of any environment to create or bring emphasis to your subjects. This technique of using the location to complement your subjects is at the core of my style. Not to mention, it is fun! Everywhere I go, I try to harness the hidden secrets that the location holds. The magic locales are there, but you have to cultivate the eye to find them. Naturally, the wedding ceremony and reception are photographed without any input from me."

He continues, "The foundation of my style is elegance with hot sauce. Those words are in my head before I bring the camera up to my eye. By 'hot

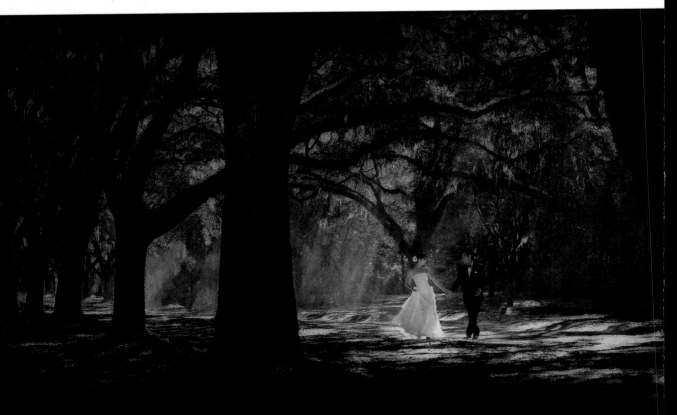

sauce,' I mean something interesting or unexpected is always present in my photos. Perhaps the composition I chose includes a piano in which part of the story is reflected on its glossy black surface. I like to surprise the viewer with something unique. I also like to create poses that don't look posed at all. I want to feel the couple's natural personality and quirks. To accomplish this, I first work on the pose and then I say something to create a natural reaction to my input.

On Posing

"The getting-ready shots, bride and groom portraits, and the wedding party portraits clearly need to be posed or those photos will not happen. A wedding photographer should be able to capture moments, emotion, and family dynamics – as well as craft natural-looking poses. The art of posing is not a style decision, it's a necessity."

> "There is an art to using the physical elements of any environment to create or bring emphasis to your subjects."

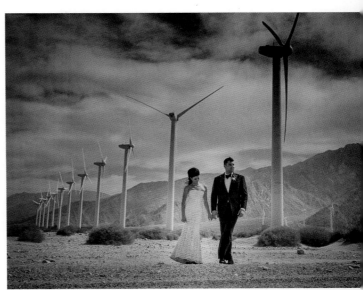

"I always describe my style as effortless, modern, timeless, and—most importantly—'spicy.' I tell my clients that I always look for ways of adding some hot sauce in my work, to keep it visually interesting. I encourage my clients to carefully explore the entire photograph because there is always an element, object, or person included somehow and somewhere in the frame that will add to the story being told in that particular photograph.

"This little exercise communicates two important pieces of information to my clients. First, it shows that the photography I provide is detail-oriented and a great deal of thought goes into each photograph. Second, it demonstrates that I am an expert at wedding photography. What I do could not be easily replicated by Uncle Bob with his shiny new camera purchased at Costco. Clients begin to see that wedding photography is a true art form. I do not want my clients to see me as just another vendor. I want them to see me as an artist capturing their

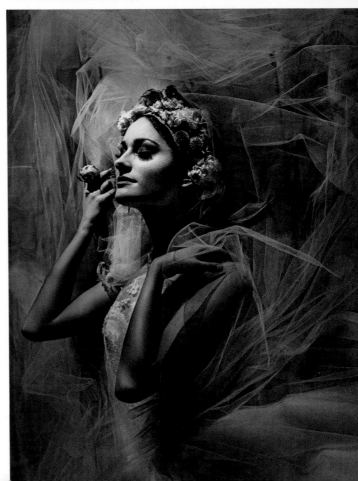

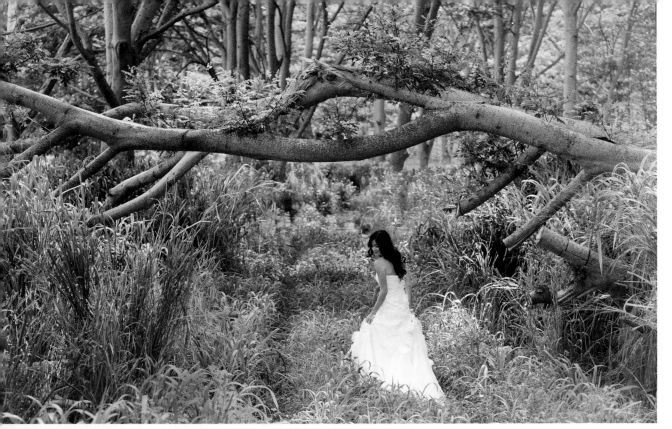

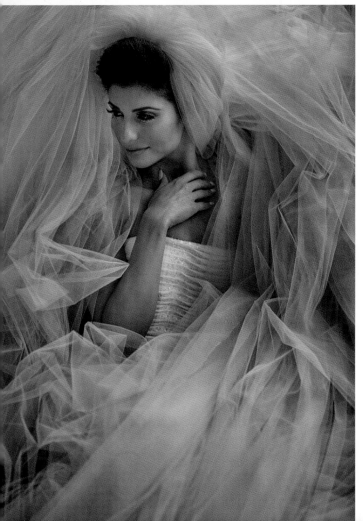

wedding. When clients respect you, they will also respect your prices and your methods. They will follow your lead and will work with you in regard to the schedule to make sure you accomplish what you set out to do. This is how I sell my style to my clients, and it has served me very well."

Creative Influences

When asked about the sources that drive his creativity, Roberto revealed, not surprisingly, that passion for his photography is one of the key elements to his success. "Staying inspired and excited about your work can literally save your business! This is a fast-moving industry. Cruising in your comfort zone and not growing will quickly prove to be your downfall."

Roberto believes that wedding photographers at the top of their game must stay challenged, motivated, energized—and, most importantly, they must reinvent themselves over and over again. "I constantly invest in fashion and trendy European

fine-art magazines. *Vanity Fair, Vogue, V,* and *W* magazines, among many others, usually showcase work that is as far from traditional as you can get.

"I need to see work that awakens my senses, that makes me wonder how the photographer came up with that idea. Photographs that have an interesting color treatment or an unusual way of using props are pure brain food. I keep exposing my brain to images that are different and have instant impact. It is this constant creative reinforcement that keeps the juices flowing. During my client meetings, my space is filled with these magazines and other forms of art. When clients walk in, I want them to feel the creative vibe in the room."

Giving Them a Great Experience

Roberto's philosophy about wedding photography is customer-centric. His primary goal is to give his clients a great experience. "I want my photography to exceed their expectations—but never at the expense of their experience with me. Many photographers forget that a wedding is a very serious ceremony celebrating the joining of two families and the beginning of a new one. A wedding is not—and never should be—a photographer's playground. I believe in training my eye and am equipped with

Roberto Factoids

Here are a few personal facts about Roberto Valenzuela:

- He is an outstanding classical guitarist.
- His dog's name is Chochos, Spanish for "sprinkles."
- His favorite movie is *Forrest Gump.* He admires Gump's tenacity in approaching the obstacles of life.
- The University of Arizona is his alma mater and he will remain a loyal Wildcat for life. He sends a shout-out to his peeps at Eller School of Business.
- He loves to watch the Food Network, although he can't cook.
- He asked out his wife (to-be) for five years before she agreed to a first date. (Determination that would make Forrest Gump proud!)
- He taught himself German in the hopes of impressing his lovely multicultural wife.
- He suffers from arachnophobia.
- Traveling is in his blood.
- Besides being an avid runner, he likes sports with extreme eye/hand coordination (*e.g.,* table tennis).
- He taught high school economics and finance at the same school he attended. ("You should have seen the double-takes by some of my previous teachers, now colleagues, on my first day of work.")
- He was invited to the White House by President Bill Clinton for winning a competition in high school.
- He builds and flies high-powered, remote-control helicopters.
- He still gets nervous before every wedding.

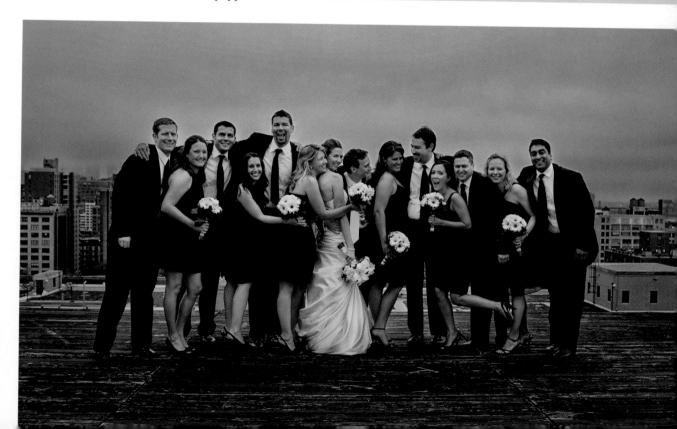

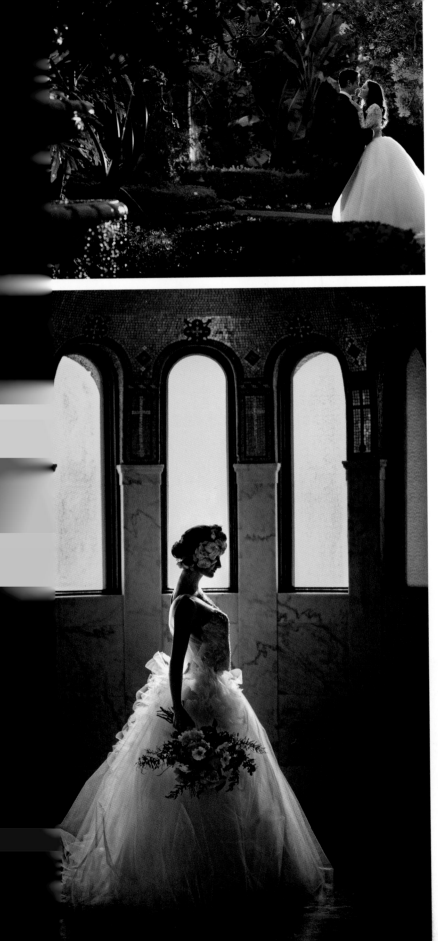

the technical knowledge to create the most dynamic and beautiful photographs possible within the client's wishes. Not every bride wants to commit six hours of her day to bride-and-groom photos. If I am given thirty minutes for bride-and-groom photos, that is precisely what I stick to. I respect my client's wishes, and it has served me well."

His Business

Since the beginning of his photography career, Roberto has always wanted to keep the overhead costs to a bare minimum. He says, "My studio space is for meeting purposes only, and it has always been a room in my home. I primarily photograph weddings, engagements, and beauty portraits for women, all of which are photographed on location. I do not operate a traditional studio—because, living in sunny Southern California, there has simply never been a need to do in-studio work. We have sunshine, beaches, and mountains—anything you need or want to get the job done on location. Naturally, if I lived in a colder-climate state, such as Minnesota, I would see it as imperative to invest in a storefront studio, especially if the focus is portraits."

Throughout the years, there have only been minor changes in how Roberto's studio is run. "I began my photography career in the digital age. Therefore, my studio's core has always been optimized for on-location digital photography. At the beginning of my career, I used to take on every aspect of the job

alone. From marketing to accounting, meeting with clients, photographing the event, editing, and album design, all the way to the delivery of the books and the follow-up—it was all done by me. As a long-term strategy, I later found this to be a huge mistake, and probably the reason why my business hit a wall within the first three years of its existence. However, I believe that knowing all the different branches of my business, hands-on, equipped me with a solid understanding of the business environment and gave me greater insight and control."

Once Roberto had a bird's-eye view of the business, he began to outsource many of the branches of his work. For example, he no longer edits photos or designs wedding books. Instead, he hired and trained an independent contractor to take care of that part of the business. He also hired an off-site CPA to take care of the books and make sure his company is in compliance with all of the federal and state tax laws.

Roberto is satisfied with the changes. "I want to focus on my work and my client's satisfaction and not be worried about how and when I'm going to file my quarterly taxes," he says. "I find my time is

"I want to focus on my work and my client's satisfaction and not be worried about how and when I'm going to file my quarterly taxes."

He says, "For my Canon system, I use a wide gamut of L-series lenses covering the entire focal length spectrum. This includes the fastest prime lenses available such as the 35mm f/1.4, 50mm f/1.2, 85mm f/1.2, and the 100mm Macro f/4.0. I use the macro lens for much of my portrait work."

In terms of lighting, he makes it a point to always have the latest in speedlight technology. "I buy four speedlights at a time. When a new speedlight becomes available, I quickly sell all of my current flash units and buy a new set of four of the latest Speedlights. It is important to my business to stay current with camera bodies and speedlights. I usually keep the lenses for many years, but the minute they begin to malfunction, it is time to sell them and upgrade," he says. "Weddings are one-time events. Dealing with old or malfunctioning equipment is not a risk I'm willing to take."

For his medium-format system, Roberto uses the retail and complete customer support of Capture Integration, which is a "one-stop shop" for all of his digital medium-format needs. His medium-format camera of choice is the Phase One 50-megapixel IQ250 CMOS sensor digital back used with various Schneider Kreuznach leaf-shutter lenses such as the 80mm f/2.8, 110mm f/2.8, 75–150mm f/4–f/5.6, and the Mamiya 120mm Macro lens. The IQ250's new Sony-built sensor offers high-sensitivity performance up to ISO 6400, exposures as short as $1/10,000$ second and as long as one hour—and a dynamic range spanning fourteen f-stops for a better ability to capture details in both shadows and highlights.

better spent going after new business—developing and maintaining relationships. A photo editor and an accountant are, in my opinion, necessary expenses if your business is going to thrive and survive."

Gear

Roberto currently photographs with Phase One medium-format gear and Canon 35mm gear. He believes, however, that once you enter the professional echelon of camera gear you can't go wrong. "I believe that Nikon, Sony, and Canon all manufacture top-notch photographic gear. I do not think one is better than the other." His recommendation to those purchasing a new system is to find a camera system that feels comfortable to you and that you enjoy shooting with.

"Your editors must work closely with you and be well trained by you to avoid wasting time and money—not to mention frustration."

"My lighting equipment for the medium-format system is the two-head Broncolor Move 1200L lighting pack, which uses a long-lasting lithium battery and internal charger. As the name suggests, the lighting kit is designed to meet my on-location needs."

In terms of computers, Roberto always defaults to Apple computers. "These computers are powerful, lightweight, stable, and perfect for travel. They also allow me to have multiple applications running in the background, handling intensive tasks without a glitch. All of my computers are loaded with the latest versions of Photoshop, Lightroom, and Microsoft Office for Mac."

Postprocessing

At the beginning of Roberto's career, he did all the postprocessing and album design himself. The twenty to thirty hours it took to process a single wedding was a huge wake-up call for him. He subsequently decided that he could no longer sustain a business where he spent all of his time editing.

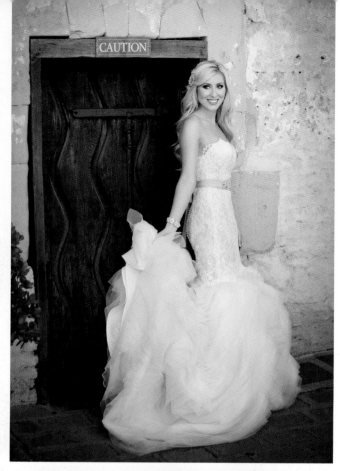

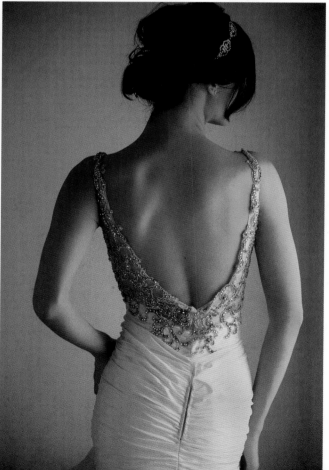

Instead, he worked harder than ever to get the photo as close to perfect as possible out of the camera.

Nevertheless, Roberto found the experience a positive one. "I feel the experience of editing, designing, making changes to the design, proofing the book to my clients, etc., provided me with invaluable skills required of a well-rounded photographer. However, this 'do it all myself' strategy only worked well in the short run. Now I have editors who work for me and take care of the edits, design, and proofing part of the job. My editors must spend countless hours with me training in order to do the edits with my look and feel. Delegating the editing of images is a great idea, but you must do it right. Your editors must work closely with you and be well trained by you to avoid wasting time and money—not to mention frustration."

No Fear of Success

As all small-business entrepreneurs experience, Roberto's studio operated on thin ice for an extended period of time. He says, "One of the biggest obstacles to overcome is complacency. Running your business within your comfort zone—with the mentality that all is well—is catastrophic. When running a business based on art, you should always be ahead of the curve. Keeping up with the latest technology and techniques and most importantly, always reinventing yourself—these things are most important in maintaining your success."

With pride he says, "I moved to Beverly Hills, CA, to photograph the big jobs. I did not wait for success to hit me, I went looking for it. But being based in Beverly Hills came with its own set of challenges. I had to find every way to differentiate myself and my services from those of my competition. One of the most successful ways I have found is to use digital medium-format camera systems in addition to the regular 35mm SLR cameras."

Learning the Craft

Looking back on the beginnings of his career, Roberto says he was always a pragmatist. "Since

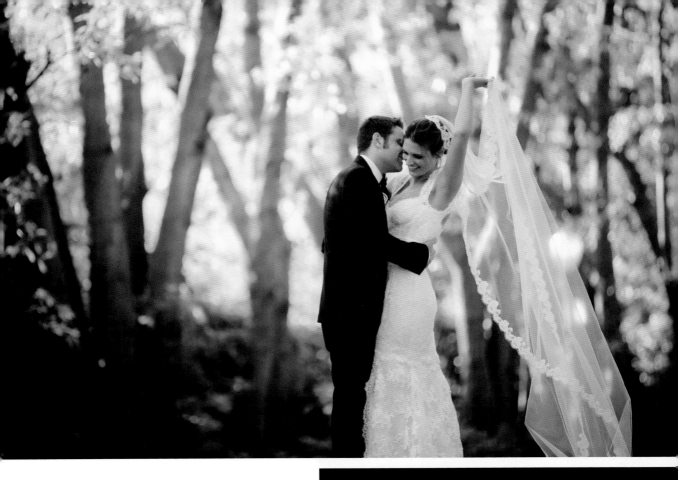

high school, I have been an educator in some form or another. I graduated from the University of Arizona with a degree in marketing and economics. This played an essential role in the success of my photography company. Knowing the ins and outs of marketing and understanding what drives prices up and down for goods and services is key to handling and running any kind of business. I believe that when people are equipped with both street smarts and formal education, they are best prepared to handle any curve ball or economic downturn life throws their way."

Roberto's college education was also important to his success in an unexpected way. "To pay for college, I decided to learn how to play classical guitar so I could earn a living and pay for tuition by teaching private guitar lessons. However, I did not even own a guitar let alone know how to play it—so that plan was definitely an uphill battle. It was a risk that paid off

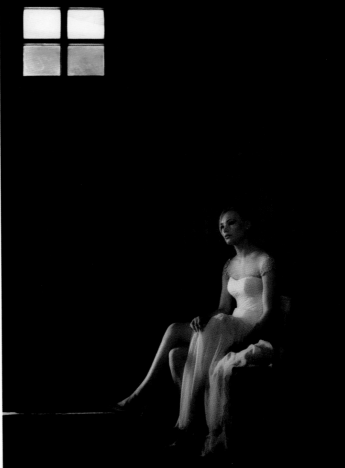

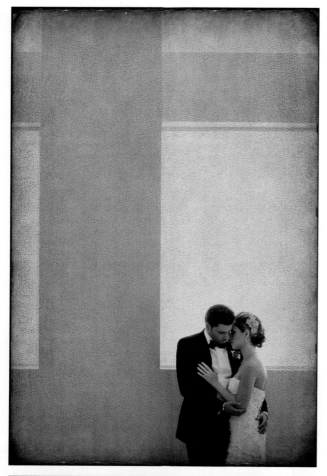

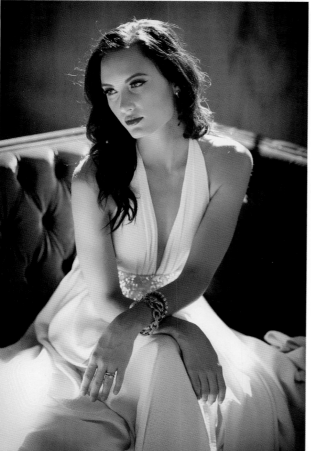

because my teaching career expanded over ten years. During that period, I taught over four thousand students how to play classical guitar.

"Learning how to play a classical instrument to the level of performing professionally taught me more than I could have hoped for. It literally rewired my brain to learn how to master concepts quickly and perform those tasks with ease. It taught me the art of deliberate practice, which is quite different from any other kind of repetitive task. It requires small goal setting, short but extremely focused practice times, defining parameters in which you must accomplish each task, etc. This type of training changed my life. I used the same techniques I used to learn and perform classical guitar professionally to train my brain to think and see like a photographer."

Asked about his influences as he studied photography, Roberto replied, "I was in the search for knowledge everywhere I could find it. I read many books on every aspect of photography. I paid for private workshops with renowned photography educators who had proven track records for providing quality education (not just social media popularity). From the wedding photography side, I learned a great deal from Jerry Ghionis and Jeff Ascough. Portrait and editorial photographers such as Annie Leibovitz and Peter Lindbergh also played a major role in my approach to photographic lighting."

A Student of Lighting

Roberto is an avid student of the technical craft of lighting. "My favorite photographic techniques, for the most part, have to do with lighting," he says. "I find lighting fascinating in all it hides and reveals, and it is what has inspired me to become a better photographer. I consider light extremely beautiful if managed properly.

"Before I make an exposure, I pay particular attention to how the light is behaving and how it is illuminating my subjects. I then use various lighting techniques—such as increasing the size of the light source to soften the light, or off-camera flash softened by a diffuser—to give my subjects a subtle pop of light

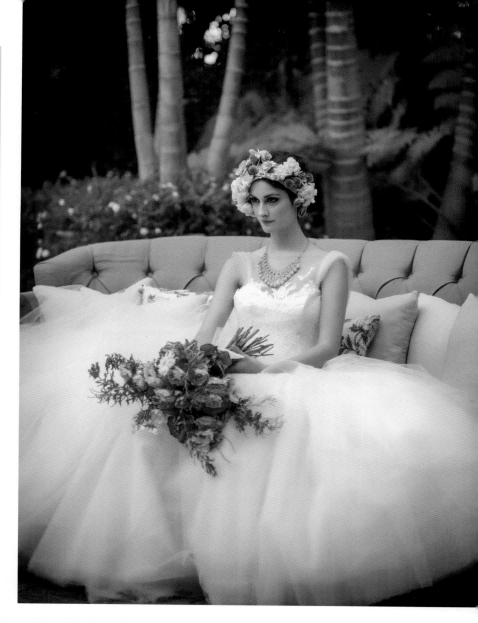

that blends seamlessly with the ambient light. That is precisely my favorite lighting technique.

"Understanding the physics of light has made photographic lighting so much easier to understand. I know why or when to use light modifiers, what purpose they have, and how my lighting decisions will affect the portrait. Studying light and really learning how it behaves has paid off ten-fold."

Game Plan

Roberto's game plan for the wedding day consists of sharpening his visual radar to interpret the best light of the day. "Before each wedding I think first and foremost about who my clients are and what their wishes are for their wedding photographs," he says. "At the beginning of my career, I used to walk around looking for locations to shoot and have a predetermined photo at each location ready to go. Now, I no longer operate that way. I simply find the beautiful light and shoot there. When the weather is cloudy, I bring plenty of speedlights to create the light when necessary. A wedding is a one-time deal, so you must be ready to create amazing images and memories—rain or shine."

Jonas Peterson
The Storyteller

With an idea that stories could be told differently, Jonas Peterson left an award-winning career in advertising to become a wedding photographer. Today, he's one of the world's most sought-after destination wedding photographers and has traveled to every corner of the world creating the simple, beautiful imagery that is the hallmark of his style. His work has been published in American *Vogue* and other magazines around the world. In 2013, he was named Best Wedding Photographer in the World by the Framed Network at their inaugural [F] Awards in Las Vegas. *American Photo* magazine also named him to their list of the world's top ten wedding photographers, and the Australian Institute of Professional Photography (AIPP) named him Professional Photographer of the Year in 2012. In the same year, he earned AIPP's award for Australian Wedding Album of the Year. In addition to his acclaim behind the camera, Jonas is a popular photography instructor who speaks regularly at national and international conferences for professional photographers. *(www.jonaspeterson.com)*

Asked to describe his job, Jonas replied, "I tell stories. I've resisted the label 'storyteller' for the longest time, but the truth is that is what I've always been. People invite me into their stories, just for a moment, and I try to re-tell them my way. Often the stories tell themselves. They lead me by the hand and all I do is listen to what I'm given.

"I've always loved photography, but I didn't get into to it until 2002," says Jonas. "I learned the basics of the darkroom and shooting black & white film. Soon thereafter I moved into digital and I haven't looked back since.

"A couple of years later, I started writing for myself, through blogs and columns in various magazines. I started to realize I could tell the stories I had in me, but I also understood I knew how to capture the stories around me, the small things that happen every day.

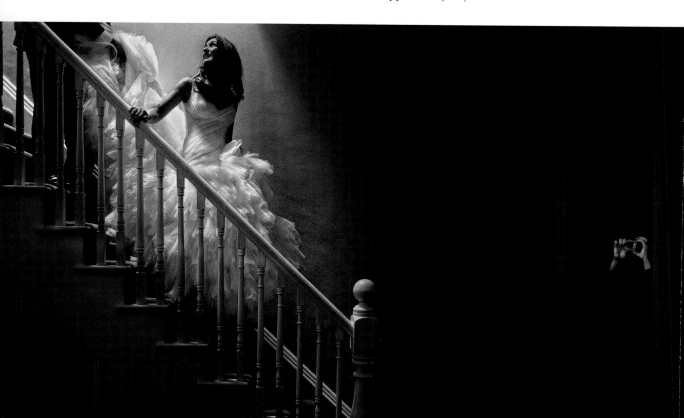

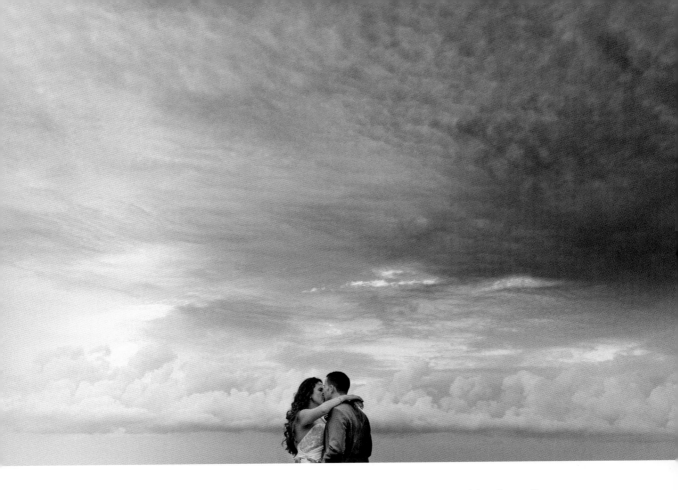

"I worked as a copywriter in advertising, writing television commercials for a living. I have always told stories, long and short—it's all I know. In many ways telling stories for the last fifteen years has made me a better visual storyteller today."

Simplicity

"My mantra in life is 'keep it simple,'" says Jonas. It's a lesson he learned before he ever picked up a camera—from the poetry of Charles Bukowski. "I realized that simple words can produce strong emotions," he says. "I've taken that understanding with me into my photography."

His Business

"For my first couple of years in business, I handled most of my business myself," says Jonas. "But as I became more busy it soon became evident I eeded help. Today, I have a full-time employee who

helps with organizing everything from client meetings and invoicing to booking my flights and everything else. Essentially, my studio is just me and my studio manager. We run a small and lean business."

In keeping with his love of simplicity, Jonas doesn't maintain a physical space for his business. "With the amount of work I do overseas and interstate, I don't have the need for a studio," he says. "I don't shoot any work there and I wouldn't have any meetings there. Yes, sometimes I miss having a

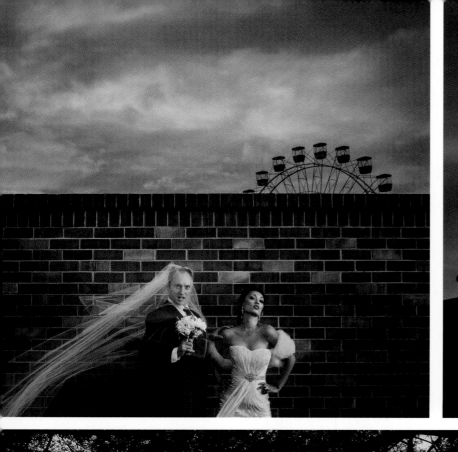

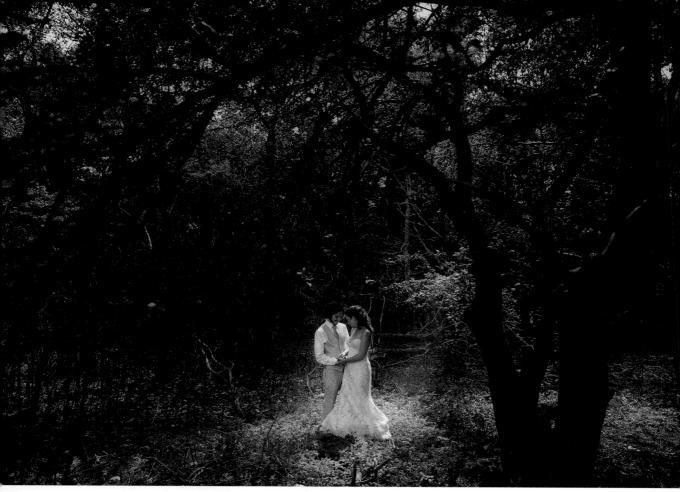

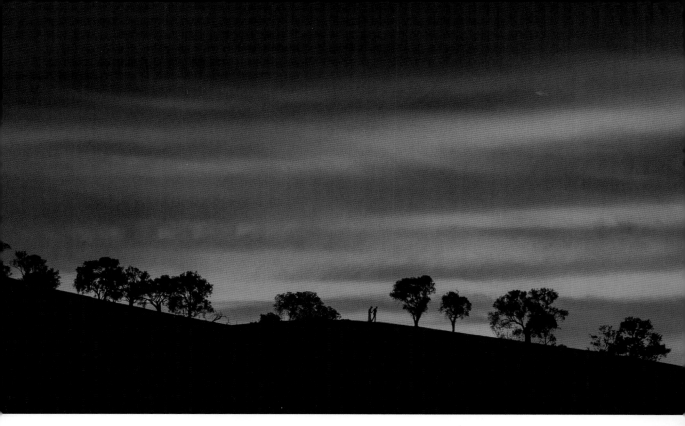

space—but the business I run has no need for it, and paying rent for a space I wouldn't use makes little to no sense. All my business and meetings are conducted online or face-to-face wherever in the world I travel. I used to have a fancy studio, but contemporary wedding photography businesses don't rely on having a physical storefront as much as the more traditional studios from the past did."

Inspiration

I asked Jonas what his sources of inspiration are and what fuels his creativity, both internally and externally. "I think movies, music, and literature have been my greatest influences. I escaped into those worlds, came back out, and wanted to create similar stories. I'm also inspired by everyday observations around me—how a girl smiles while reading her favorite book down at the café across from my house.

"I avoid looking at wedding photography. The work I produce is an extension of me and I don't want to mix other wedding photographers into the recipe. That said, I don't really look at photography for direct inspiration at all. I love photography and study it every day, but it's not like I'll go to a Mary Ellen Mark exhibition and steal what she does and bring it back into my work. My work is me and all the experiences I've had. The ups and the downs. Hopefully, that comes across in my work."

Gear

Asked about what types of equipment and computers and software he uses, Jonas said, "In many ways I see myself more as a storyteller than a photographer, and the equipment I use is secondary to telling a good story. But I need good tools to do what I do. Today, I shoot with two Canon 5D Mark III cameras and a range of prime lenses from 14mm to 200mm. I also own some zooms, but I prefer to work with primes, both for the look you get but also because I feel zooms make me lazy. I want to be a part of the stories I shoot, not observe them from a corner without having to move." He adds, "All my personal work is shot on film, so I do own a number of old film cameras as well."

"I work on an Apple laptop. At home it's connected to a 27-inch display—but since I travel so much, I need my main computer to be with me at all times. For me, it makes no sense to have a studio computer and a laptop, so today I only use one. All my work is saved on external drives, larger ones in the studio and smaller ones on the road. I batch edit my images in Adobe Lightroom, but all my individual hero images are edited in Photoshop."

Game Plan

So what is Jonas's wedding-day game plan? "The plan is to not have an approach," says Jonas. "I simply react to what happens in front of me. When it comes to my portraiture, I try to just go with my gut feeling there, too. I don't pose much; instead, I get my couples comfortable enough to interact in front of me."

> "The plan is to not have an approach. I simply react to what happens in front of me."

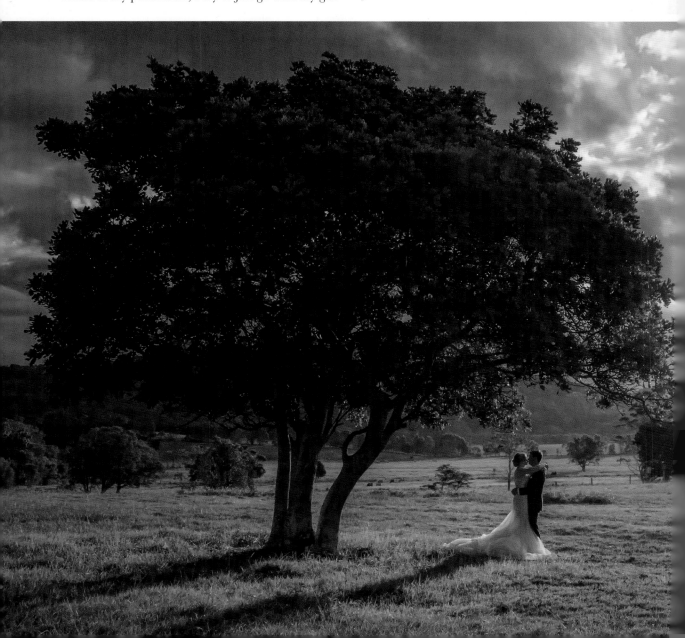

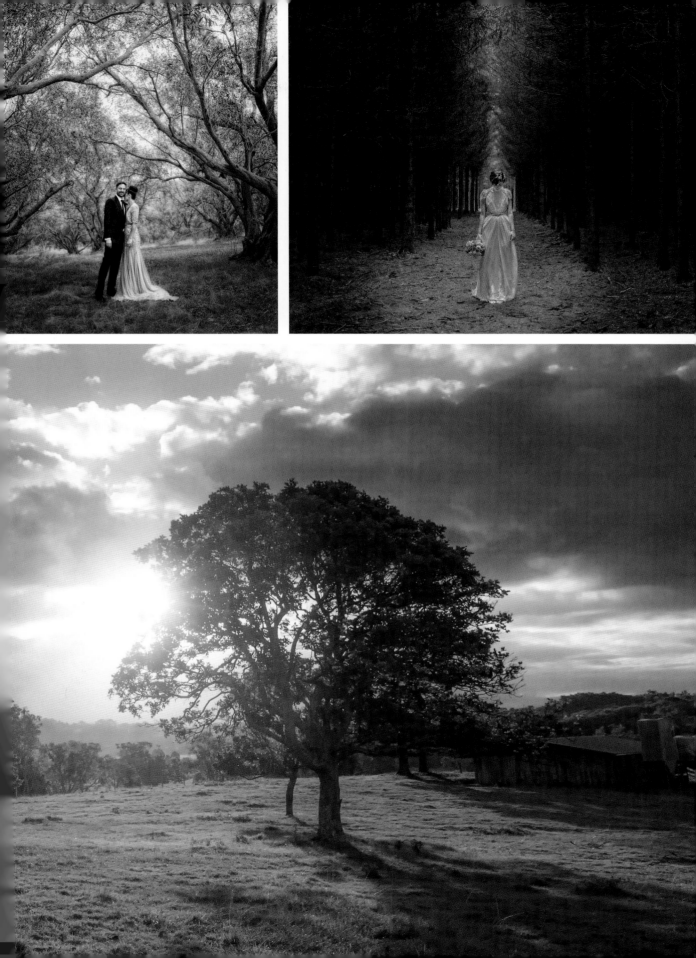

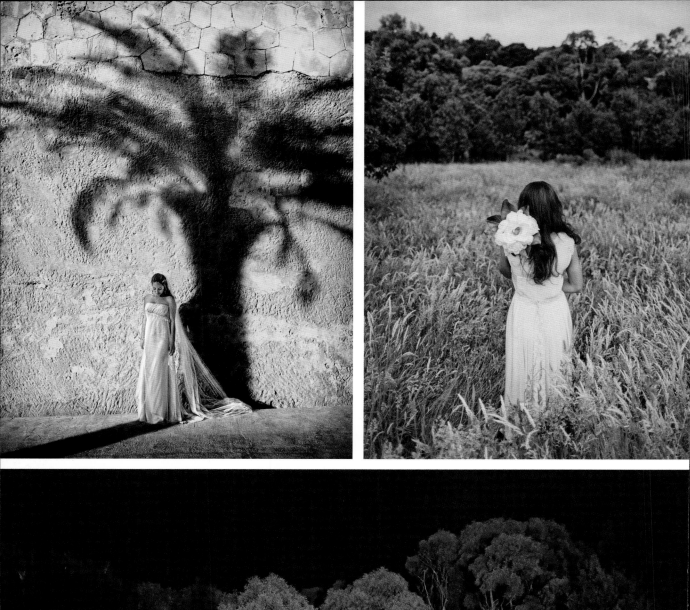
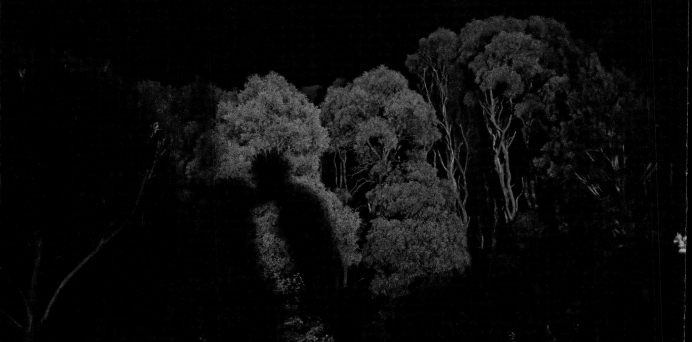

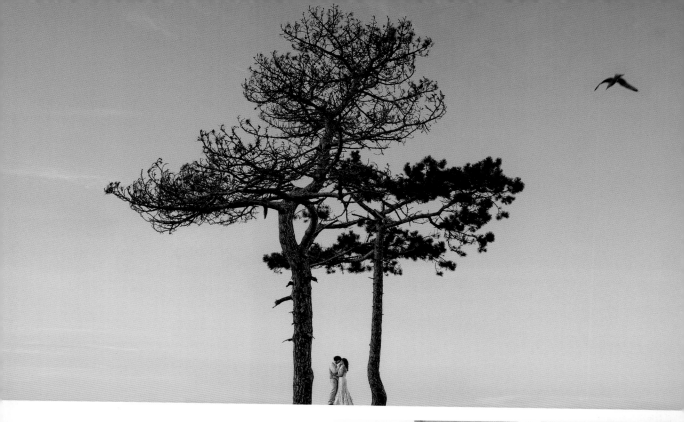

Postproduction

"I do all my postprocessing myself. My editing is generally very light. I try to nail things in-camera as much as I can—all manual settings even down to the exact white balance I'm after. I shoot in RAW, but only because of the safety it gives me. I could just as easily shoot in JPEG. When I started out, I could spend days editing my weddings. Today, I have a wedding edited and done in half a day."

Secrets of His Success

When I asked Jonas about his success in the industry, he replied, "I started shooting weddings in 2008, and in many ways it was the right time and the right place for an alternative to the more established wedding photographers.

"I found that a lot of wedding photography looked the same and it had lost touch with the people I knew who were getting married around me. I wanted to tell more real stories, packed with real people and real emotion, and not create the same set-up story every Saturday.

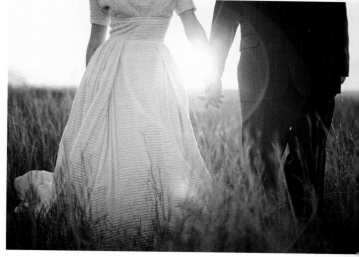

"I have always been interested in social media, and I've played that game better than many others. I make sure my work is seen by many people and published on blogs (and sometimes magazines). My work is me, and as long as I try and stay true to what drives me and the stories I'm interested in telling, I will always be different from the competition."

Favorite Techniques

When asked about his frequently used techniques and why he favors them, Jonas replied, "I keep my photography as simple as possible. I often find that techniques—lighting and other things that require setting something up—take away from the story I'm trying to document, so I generally stay away from them. With that said, I have been known to use a tilt-shift lens for portraits now and then. That's probably as close as I come to using a 'technique.'"

His Style

Along those same lines, Jonas does not see himself as one particular type of wedding photographer. "I don't believe in labels, my photography is me and it's influenced by hundreds of things. Some of it is documentary; other imagery is influenced by classic portraiture, fine-art, paintings, music—you name it. My photography is everything I am.

"I want to tell the story of my couple, their friends, and families. I don't like setting anything up. Instead, I react to what's happening in front of me. I try to capture each wedding a new way. Coming home with certain shots because I know they work bores me to no end. Why do wedding photographers keep shooting dresses hanging from windows? Is that really the best way to shoot a dress? Or do we simply shoot what others have shot before us because we assume our couples want those shots?

"Wedding photography has got its rules, and in some ways it's

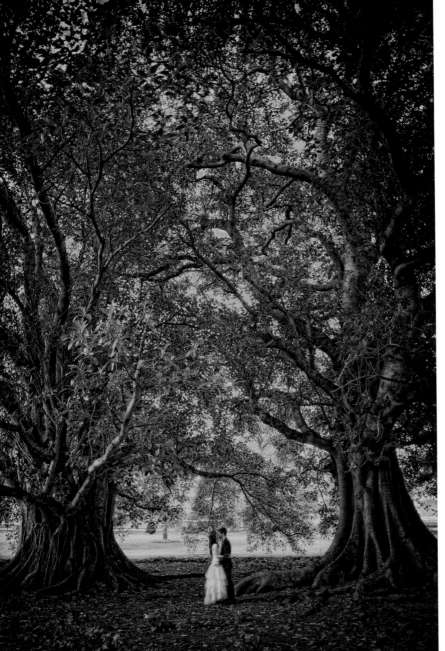

a very orchestrated event—you know what's going to happen, you know when people are going to do what. And yet you know nothing. Every wedding is completely different. Every couple adds something new to the mix. I love being there to capture their day, and I hate being in the way. You won't find me running around telling people what to do, hauling flashes and umbrellas from room to room, setting up shots I'm good at. I try and walk in with a sense of naivety. I try to capture the events as they happen.

"I know the story is there, all the beauty and drama, all the characters and the details. I've started to trust the day. It will be beautiful and people will be relaxed with me around. I don't have to tell them what to do or where to look. I watch the story unfold and try to capture every bit of it. Today, I work as a photographer capturing these things the way I see them."

In Ten Years

"I stopped making a five-year plan many years ago. Life is too short," Jonas says. "I try to live in the moment and enjoy that as much as I can. Sure, I know I want to write more—my father was a writer—and I don't see myself shooting weddings forever, but as long as the fire still burns, I will be shooting weddings and telling stories that matter to me."

"Why do wedding photographers keep shooting dresses hanging from windows? Is that really the best way to shoot a dress? Or do we simply shoot what others have shot before us?"

Index

OTHER BOOKS FROM
Amherst Media®

Modern Bridal Photography Techniques

Get a behind-the-scenes look at some of Brett Florens' most prized images—from conceptualization to creation. *$29.95 list, 7.5x10, 160p, 200 color images, 25 diagrams, order no. 1987.*

Shoot to Thrill

Acclaimed photographer Michael Mowbray shows how speedlights can rise to any photographic challenge—in the studio or on location. *$27.95 list, 7.5x10, 128p, 220 color images, order no. 2011.*

Location Lighting Handbook for Portrait Photographers

Stephanie and Peter Zettl provide simple techniques for creating elegant and expressive lighting for subjects in any location. *$27.95 list, 7.5x10, 160p, 200 color images, order no. 1990.*

Photograph the Face

Acclaimed photographer and photo-educator Jeff Smith cuts to the core of great portraits, showing you how to make the subject's face look its very best. *$27.95 list, 7.5x10, 128p, 275 color images, order no. 2019.*

We're Engaged!

Acclaimed photographers and photo instructors Bob and Dawn Davis reveal their secrets for creating vibrant and joyful portraits of the happy couple. *$27.95 list, 7.5x10, 128p, 180 color images, order no. 2024.*

ABCs of Beautiful Light

A Complete Course for Photographers

Rosanne Olson provides a comprehensive, self-guided course for studio and location lighting of any subject. *$27.95 list, 7.5x10, 128p, 220 color images, order no. 2026.*

The Beautiful Wedding

Tracy Dorr guides you through the process of photographing the authentic moments and emotions that make every wedding beautiful. *$27.95 list, 7.5x10, 128p, 180 color images, order no. 2020.*

Photograph Couples

Study images from 60 beautiful wedding and engagement sessions. Tiffany Wayne shows what it takes to create emotionally charged images couples love. *$27.95 list, 7.5x10, 128p, 180 color images, order no. 2031.*

Set the Scene

With techniques and images from nearly a dozen top pros, Tracy Dorr shows you how using props can inspire you to design more creative and customized portraits. *$27.95 list, 7.5x10, 128p, 320 color images, order no. 1999.*

The Art of Engagement Portraits

Go beyond mere portraiture to design works of art for your engagement clients with these techniques from Neal Urban. *$27.95 list, 7.5x10, 128p, 200 color images, order no. 2041.*

One Wedding

Brett Florens takes you, hour by hour, through the photography process for one entire wedding—from the engagement portraits, to the reception, and beyond! *$27.95 list, 7.5x10, 128p, 375 color images, order no. 2015.*

How to Photograph Weddings

Twenty-five industry leaders take you behind the scenes to learn the lighting, posing, design, and business techniques that have made them so successful. *$27.95 list, 7.5x10, 128p, 240 color images, order no. 2035.*

The Right Light

Working with couples, families, and kids, Krista Smith shows how using natural light can bring out the best in every subject—and result in highly marketable images. *$27.95 list, 7.5x10, 128p, 250 color images, order no. 2018.*

Dream Weddings

Celebrated wedding photographer Neal Urban shows you how to capture more powerful and dramatic images at every phase of the wedding photography process. *$27.95 list, 7.5x10, 128p, 190 color images, order no. 1996.*

Light a Model

Billy Pegram shows you how to create edgy looks with lighting, helping you to create images of models (or other photo subjects) with a high-impact editorial style. *$27.95 list, 7.5x10, 128p, 190 color images, order no. 2016.*

Nikon® Speedlight® Handbook

Stephanie Zettl gets down and dirty with this dynamic lighting system, showing you how to maximize your results in the studio or on location. *$34.95 list, 7.5x10, 160p, 300 color images, order no. 1959.*

Lighting and Design for Portrait Photography

Neil van Niekerk shares techniques for maximizing lighting, composition, and overall image designing in-studio and on location. *$27.95 list, 7.5x10, 128p, 200 color images, order no. 2038.*

The Speedlight Studio

Can you use small flash to shoot all of your portraits and come away with inventive and nuanced shots? As Michael Mowbray proves, the answer is a resounding yes! *$27.95 list, 7.5x10, 128p, 200 color images, order no. 2041.*

The Beckstead Wedding

Industry fave David Beckstead provides stunning images and targeted tips to show you how to create images that move clients and viewers. *$27.95 list, 7.5x10, 128p, 200 color images, order no. 2045.*

Other Books by Bill Hurter

Portrait Photographer's Handbook, *3rd ed.*

This step-by-step guide leads you through all phases of portrait photography. *$34.95 list, 8.5x11, 128p, 175 color photos, order no. 1844.*

Group Portrait Photography Handbook, *2nd ed.*

Bill Hurter and top pros provide tips for composing, lighting, and posing group portraits in the studio and on location. *$34.95 list, 8.5x11, 128p, 120 color photos, order no. 1740.*

Rangefinder's Professional Photography

Editor Bill Hurter shares over 100 image "recipes," showing you how to shoot, pose, light, and edit fabulous images. *$34.95 list, 8.5x11, 128p, 150 color photos, index, order no. 1828.*

Existing Light TECHNIQUES FOR WEDDING AND PORTRAIT PHOTOGRAPHY

Bill Hurter and a host of pros show you how to work with window, outdoor, fluorescent, and incandescent light. *$34.95 list, 8.5x11, 128p, 150 color photos, index, order no. 1858.*

Master Posing Guide for Wedding Photographers

Bill Hurter shows you posing ideas that make your clients look their best and capture the joy of the event. *$34.95 list, 8.5x11, 128p, 180 color images and diagrams, index, order no. 1881.*

Wedding Photographer's Handbook, *2nd ed.*

Bill Hurter teaches you how to exceed your clients' expectations before, during, and after the wedding. *$34.95 list, 8.5x11, 128p, 150 color images, index, order no. 1932.*

BILL HURTER'S Small Flash Photography

Learn to select and place small flash units, choose proper flash settings and communication, and more. *$34.95 list, 8.5x11, 128p, 180 color photos and diagrams, index, order no. 1936.*

Portrait Mastery in Black & White

Tim Kelly's evocative portraits are a hit with clients and photographers alike. Emulate his classic style with the tips in this book. *$27.95 list, 7.5x10, 128p, 200 images, order no. 2046.*

Engagement Portraiture

Tracy Dorr demonstrates how to create masterful engagement portraits and build a marketing and sales approach that maximizes profits. *$19.95 list, 8.5x11, 128p, 200 color images, index, order no. 1946.*

Off-Camera Flash

TECHNIQUES FOR DIGITAL PHOTOGRAPHERS

Neil van Niekerk shows you how to set your camera, choose the right settings, and position your flash for exceptional results. *$34.95 list, 8.5x11, 128p, 235 color images, index, order no. 1935.*

On-Camera Flash TECHNIQUES FOR DIGITAL WEDDING AND PORTRAIT PHOTOGRAPHY

Neil van Niekerk teaches you how to use on-camera flash to create flattering portrait lighting anywhere. *$34.95 list, 8.5x11, 128p, 190 color images, index, order no. 1888.*

Step-by-Step Wedding Photography, 2nd ed.

Damon Tucci offers succinct lessons on great lighting and posing and presents strategies for more efficient and artful shoots. *$27.95 list, 7.5x10, 128p, 225 color images, order no. 2027.*

Wedding Photojournalism

THE BUSINESS OF AESTHETICS

Paul D. Van Hoy II shows you how to create strong images, implement smart business and marketing practices, and more. *$19.95 list, 8.5x11, 128p, 230 color images, index, order no. 1939.*

BRETT FLORENS' Guide to Photographing Weddings

Learn the artistic and business strategies Florens uses to remain at the top of his field. *$19.95 list, 8.5x11, 128p, 250 color images, index, order no. 1926.*

500 Poses for Photographing Brides

Michelle Perkins showcases an array of head-and-shoulders, three-quarter, full-length, and seated and standing poses. *$34.95 list, 8.5x11, 128p, 500 color images, index, order no. 1909.*

500 Poses for Photographing Couples

Michelle Perkins showcases an array of poses that will give you the creative boost you need to create an evocative, meaningful portrait. *$34.95 list, 8.5x11, 128p, 500 color images, order no. 1943.*

500 Poses for Photographing Groups

Michelle Perkins provides an impressive collection of images that will inspire you to design polished, professional portraits. *$34.95 list, 8.5x11, 128p, 500 color images, order no. 1980.*